IMAGES
of America

ISLES OF SHOALS

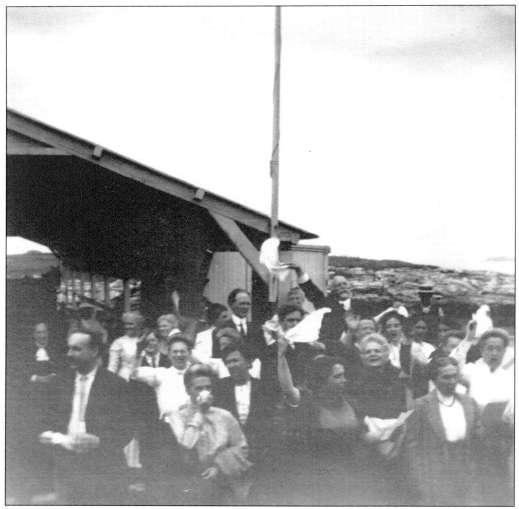

For thousands of conference goers who visited the Isles of Shoals year after year, there could be no sweeter moment than stepping onto the dock at Star Island and renewing old acquaintances with a wave and a smile.

On the cover: Long before the beginning of the conference era on Star and Appledore Islands, the Boston Commandery Knights Templar had discovered the beauty of summer on the Isles of Shoals, as evidenced by this photograph taken in the 1880s. (Courtesy of the Star Island Corporation Collection at the Portsmouth Athenaeum.)

IMAGES of America
ISLES OF SHOALS

Donald Cann, John Galluzzo,
and Gayle Kadlik

Copyright © 2007 by Donald Cann, John Galluzzo, and Gayle Kadlik
ISBN 978-0-7385-5453-2

Published by Arcadia Publishing
Charleston, South Carolina

Printed in the United States of America

Library of Congress Catalog Card Number: 2007923781

For all general information contact Arcadia Publishing at:
Telephone 843-853-2070
Fax 843-853-0044
E-mail sales@arcadiapublishing.com
For customer service and orders:
Toll-Free 1-888-313-2665

Visit us on the Internet at www.arcadiapublishing.com

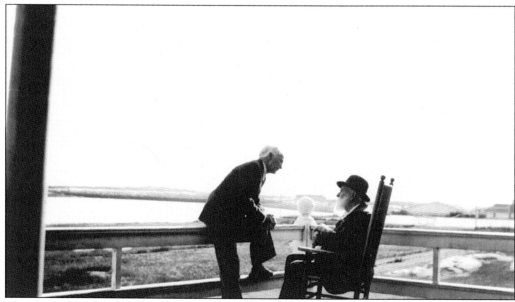

The story of the Isles of Shoals is the story of the Laighton family. Here, Oscar Laighton (seated in the rocking chair), the longest living and the last surviving member of the family that settled on White Island in the 1830s, chats with friend Thomas Rees. The Laightons saw the islands change from fishing capital, to tourism center, to religious conference retreat. More than bystanders, they led the islands through those transformations.

Contents

Acknowledgments		7
Introduction		8
1.	Real Old Shoalers	9
2.	A Lighthouse and a Lifesaving Station	23
3.	Appledore Island	35
4.	Celia Thaxter's Friends and Family	45
5.	Conferences on Star Island	57
6.	Special Places	77
7.	Caves and Waves	89
8.	Uncle Oscar Laighton	101
9.	Boats and More Boats	113

Acknowledgments

The authors took this project on with the blessing of the Star Island Corporation, and without their generosity and helpfulness, this book would not exist. Particular thanks are extended to the Star Island Corporation Board of Directors, and the many permanent staff members of the organization, including Amy Lockwood, Kat Waters, Joe Watts, Brian Winters, Karen Muldoon, Justina Kobe Maji, and Melissa Saggerer, the Vaughn Cottage curator in 2005 and 2006.

Much of our research as well as the process of building the book took place at the Portsmouth Athenaeum, and our heartfelt thanks goes out to the staff there: Tom Hardiman, Robin Silva, Carolyn Marvin, Ursula Wright, Susan Kindstedt, and Nancy Mulqueen.

Several other people proved absolutely invaluable to the completion of this project, including Donna Titus, Tom and Susy Mansfield, Dan Fenn, Sue Reynolds, Dave Reynolds of the Shoals Marine Laboratory on Appledore Island, Walter Hickey and Joanie Gearin at the National Archives and Records Administration-Northeast Region office in Waltham, Massachusetts, and Dr. Robert W. Browning, the historian of the United States Coast Guard, and historian Chris Havern from that office.

Donald Cann would like to thank his wife, Janet, his daughters, Jessica and Emily Cann. He completed this project working in memory of his parents, Charles I. and Edith Cann, the grandparents of five "Pelicans." John Galluzzo got his usual support from his wife, Michelle, for which and for whom he is eternally grateful. Gayle Kadlik would like to thank all of those who supported her in this project, including Jeannie Sanborn, Sally Aalto, Marilyn Arnone, and Leonard and Gladys Mathieu. She especially would like to say thanks to her husband, John and their three sons, Johnny, James and Christian.

This book is dedicated to all "old Shoalers."

Introduction

The Isles of Shoals consist of nine tiny islands half a dozen miles off the New England coast. Appledore (formerly Hog), Duck, Malaga, Smuttynose (or Haley's), and Cedar Islands are annexed to Maine, while Star, White, Seavey, and Lunging (formerly Londoner's) Islands lie in New Hampshire waters. Volumes can be written on the rich, varied, and significant history of these islands. Our mission is to offer the reader a photographic glimpse into the colorful history and inhabitants of the Isles of Shoals.

Undoubtedly, both the geographical location and the ecological features of the Isles of Shoals drew fishermen to this group of seemingly barren islands. Early explorers of the New England coast noted that the natural harbor created by the rocky archipelago and the deep waters that surrounded it provided an excellent opportunity for a profitable fishing station. Its convenient offshore location afforded close proximity to the mainland, yet enough distance to allow the islanders a largely autonomous existence and protection from the occasional unfriendly local Native American. These permanent colonizers of the early 1600s were primarily fishermen and their families from English seaports who were already familiar with the islands as a lucrative summer fishing station. Those who chose to permanently inhabit the rugged territory of these islands were, unquestionably, a fiercely independent, courageous, and robust lot.

Throughout the 17th century, the Isles of Shoals prospered, and its fishermen and merchants were among the wealthiest in New England. A commodity called "dunfish," a cured cod very desirable in Europe and other parts of the world, was produced on these islands. Aside from the abundance of large codfish in the surrounding waters, the climate was particularly favorable for drying the fish. The combination of moist air and constant ocean breezes ensured an even curing that made the renowned dunfish produced there superior to any other, and the standard price for it on the world market was set at the Isles of Shoals.

The 18th century brought a decline of trade and industry at the Isles of Shoals partly due to commerce regulations imposed by the province of New Hampshire. Subsequently at the time of the American Revolution, islanders were ordered to evacuate to the mainland. The decree alluded to a concern that the inhabitants might be compelled to assist the enemy due to their fairly defenseless position. Families actually floated their homes to the mainland, and some of those pre-Revolutionary homes still adorn the streets of York.

From the American Revolution to the mid-19th century, the majority of fishermen and their families that stayed or returned to the islands lived in impoverished, perhaps even uncivilized, conditions. The community at that time was often referred to as "wretched," with reports of ignorance, excessive drunkenness, adultery, and other lawlessness. Historian Dr. Joseph Warren

questioned whether history did an injustice to those inhabitants, for little was said of the many virtues they had to possess to persevere and endure the rugged existence on those rocks. Warren suggested that the fundamental values of those Shoalers would not suffer greatly in a comparison with fishermen and sailors of other New England seaports of the era.

With the demise of the fishing industry came the birth of tourism at the Isles of Shoals. Thomas B. Laighton, businessman and politician from Portsmouth, acquired several of the islands. By 1848, Laighton erected and operated a successful hotel on the largest of the isles, then called Hog Island. He renamed the island Appledore, after the earliest settlement there, and called the hotel Appledore House. Laighton was certain this would have more appeal to tourists than "Hog House" on Hog Island. Thus began a new era of prosperity at the Isles of Shoals based on tourism. The Isles of Shoals became a favorite summer resort for many of the most revered authors, artists, musicians and politicians of the era. Laighton's daughter, Celia Laighton Thaxter, grew up among this circle of notables to become an author and artist herself. If her father was known as "King of the Islands," and he was, surely she was the princess of the Isles of Shoals.

Once again, the turn of a century brought change to the Isles of Shoals. Following the Civil War, Star Island natives found themselves owing great sums of money in the form of a war tax to the government, having pledged to pay the tax in lieu of sending their men to fight. Unable to pay, most residents sold their property to entrepreneur John Poor. Poor built the luxurious Oceanic Hotel, which rivaled the Appledore House. Equipped with an elevator and boasting the only pier on the islands able to accommodate large steamers, he was instantly successful. The original Oceanic Hotel burned in 1875, but Poor quickly rebuilt, and the second Oceanic Hotel was operating the following season. As competition from resorts on the mainland increased, the 20th century brought the end of the resort era and the beginning of the conference era at the Isles of Shoals.

Since 1897, Star Island has been host to religious and educational conferences each summer with a brief hiatus during World Wars I and II. The legendary Appledore House burned in 1914, but the Oceanic Hotel is still in existence. The Star Island Corporation now owns Star and Appledore Islands. It operates the hotel, accommodates over 260 conference guests each week, and is a seasonal home to over 100 employees. Appledore Island is leased to Cornell University and the University of New Hampshire for the operation of the Shoals Marine Laboratory.

For those readers who wish to further their scholarship on this subject, several books provide a general history of the Isles of Shoals including *The Isles of Shoals: An Historical Sketch*, *The Isles of Shoals: A Visual History*, and *The Isles of Shoals in Lore and Legend*. Among the Isles of Shoals, *Ninety Years at the Isles of Shoals*, and *Sprays of Salt: Reminiscences of a Native Shoaler* offer descriptive and entertaining firsthand accounts of life on the Isles of Shoals. To Celia Thaxter enthusiasts, we recommend *The Life and Letters of Celia Thaxter* and *One Woman's Work: The Visual Art of Celia Laighton Thaxter*. In addition, *Gosport Remembered* has some interesting 19th century photographs not published in other works.

The authors of this book are pleased to present this collection of historical images so graciously allowed by the Star Island Corporation. This collection is on permanent loan to the Portsmouth Athenaeum. Some of the photographs here have been published in various other books, but never before has the collection been assembled in one volume. Journey with us now as we further explore the Isles of Shoals—Appledore, Duck, Malaga, Smuttynose, Cedar, Star, White, Seavey, and Lunging—as we step into the past and experience "whispers of the times that were."

One
REAL OLD SHOALERS

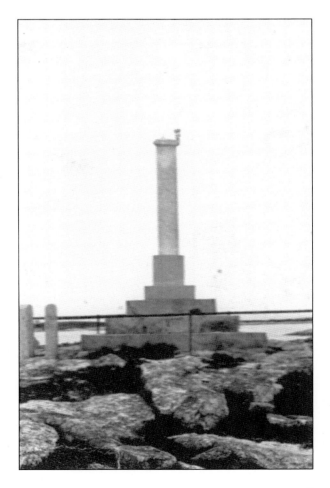

Capt. John Smith was an early explorer of the New England coast. Visiting the area in 1614, Smith is credited with being the first to chart these barren islands. He was so smitten with this group of islands that he named them for himself—Smith Isles. However, sailors already referred to them as the Isles of Shoals, to which the name soon reverted. Although many historians feel the name refers to the shoaling or schooling of fish, Rev. Victor Bigelow argued that the "sensational lines of shoals in the open sea" would surely have gotten sailors' attention over the shoaling of fish: "shoals of fishes are of slight notice to a sailor compared with shoals of rocks which he must respect or perish." Rev. Daniel Austin of Portsmouth first erected this monument to Smith on Star Island in 1864 in commemoration of the 250th anniversary of Smith's visit to the Isles of Shoals. In this image from 1881, note the original configuration of the monument, with its tall shaft and the remnants of what was the adornment of three Turks' heads.

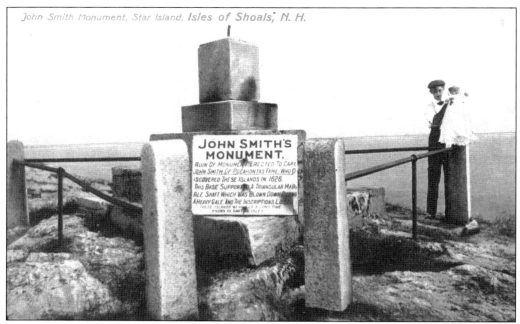

This postcard image was taken in the early 1900s. The three Turks' heads originally fastened to the top of a tall marble shaft represented three Turkish men beheaded by Smith during duels in Transylvania. The shaft and heads were destroyed in a fierce storm. Note the erroneous discovery date of 1626 on the crude wooden sign.

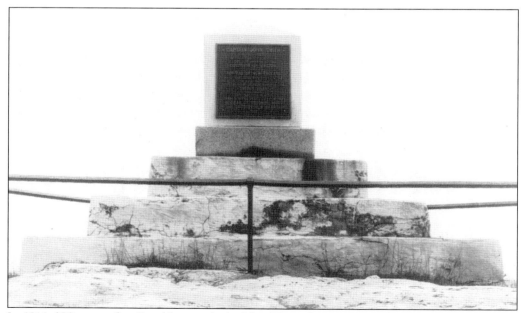

In 1914, 300 years after Smith's arrival, the New Hampshire Society of Colonial Wars restored the base and rededicated the monument. This commemoration was held following the dedication of the Tucke Memorial and was attended by nearly 250 people. The metal sign on the permanent reconstruction states the correct information. This is how the monument appears today.

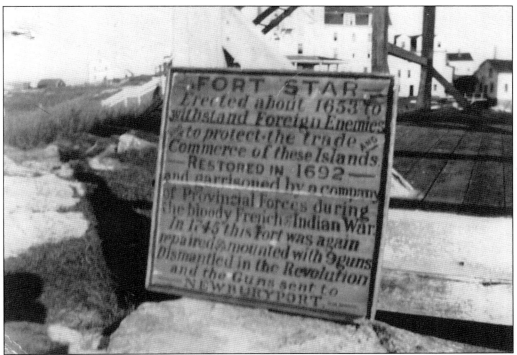

In 1921, a wooden sign recounting the interesting history of Fort Star was found under the summerhouse on Star Island. The mid-17th century was a prosperous time for the Isles of Shoals, and the proprietors and inhabitants evidently became concerned about protecting their interests. In 1653, a stone fort was erected high on the western end of Star Island and outfitted with two large cannons. Reconstructed in 1692 and again in 1745, the fort was manned with an additional nine guns. These were moved to Newburyport at the time of the American Revolution.

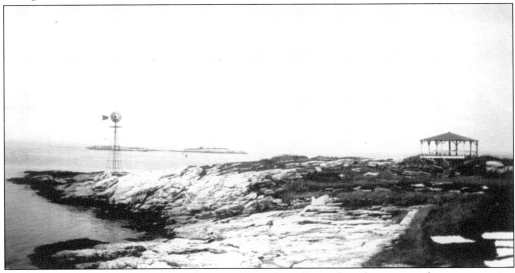

Today the summerhouse sits upon the site of Fort Star. On a clear day, it provides an expansive view, including all nine islands, from Cape Porpoise in Maine to Cape Ann in Massachusetts. Note the windmill used to generate power and Lunging Island in the background.

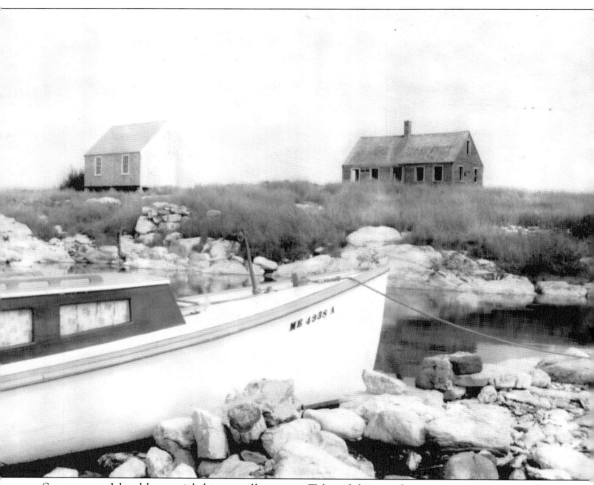

Smuttynose Island has a rich history all its own. Tales of shipwrecks, pirates, treasure, murder, and even ghosts abound. As a bustling community known as "Church Island" in the 1600s, it was home to a brick meetinghouse, courthouse, a good well and many homes and fish houses. When New Hampshire separated from Massachusetts, the inhabitants migrated from Hog and Smuttynose to Star Island to avoid taxation and left the islands essentially abandoned. In the 1700s, Samuel Haley settled on Smuttynose Island, or Haley's Island, as it would come to be known during this period. Throughout the 18th century, Samuel Haley's enterprises prospered. A bakery, brewery, distillery, saltworks, blacksmith's shop, gristmill, and cooper's shop were still in operation in 1800. This mid-20th-century image was taken at high tide from the stone pier built by Haley. Today the Haley house (right) has been restored to its original 18th century style, and its photograph adorns the label of a locally brewed ale. Gull Cottage (left) was built in the late 1950s. The privately owned island is maintained by stewards.

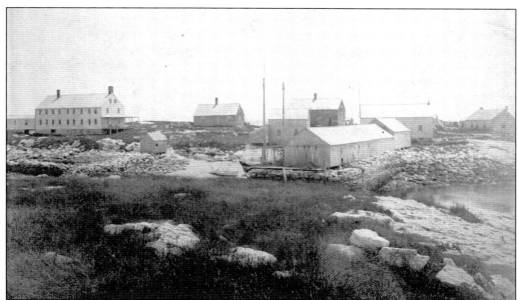

The above image of Smuttynose Island was taken from Malaga Island around 1880. Tiny Malaga Island is connected to Smuttynose Island by a seawall, providing a fine cove at high tide and sandy beach at low tide. From the left is the Mid-Ocean House of Entertainment, built by Haley. Next is the Haley house, with the family's cemetery located nearby. Behind the small fish house is the Hontvet house, scene of the gruesome Smuttynose murders of 1873. The Long House on the stone pier was moved to Cedar Island around 1890. Note the two-masted sailing vessel grounded at low tide.

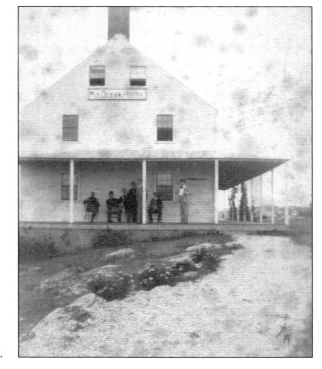

In 1839, Thomas Laighton bought what had become known as Haley's Island, along with Hog and Malaga Islands, and operated the Mid-Ocean House, shown here. Authors Richard Henry Dana and Nathaniel Hawthorne were two notable guests there. The small hotel burned in 1911.

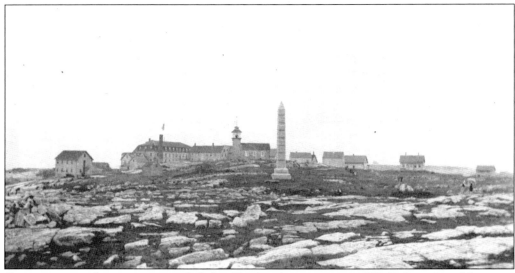

Quite a roster of ministers attended the Shoalers beginning in 1637. Perhaps loved best was Rev. John Tucke, who tended the flock for over 40 years, serving as minister, teacher, friend, and physician. Fortunately Tucke kept good records during this period dating 1732 to 1773. The Tucke Monument, the tall obelisk just right of center, was erected on Star Island in 1914 and dedicated by the New Hampshire Historical Society.

The original parsonage on Star Island was built by Reverend Tucke. It was dismantled and floated to York during the American Revolution. This building, erected in 1802, was the second parsonage and burned in 1905. A stone parsonage built in 1927 now stands on its foundation. The turnstile in the foreground, an attempt to separate grazing animals from humans, has been reproduced and stands today in the same location.

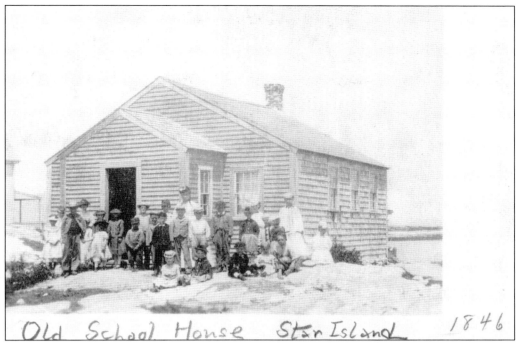

This photograph of a one-room schoolhouse with a small vestibule in front was taken on Star Island in 1846. An early teacher was the much-loved Hannah Peabody. For several years beginning in 1823, she taught her 20 or so students to knit, sew, spin wool, and manufacture fish nets, a handy skill in a village dependent upon fishing for its livelihood.

The Beebe cemetery, with its three tiny graves, lies in a hollow on Star Island. Mitty Beebe attended school on the mainland. Her father, Rev. George Beebe, served as minister, doctor, and more from 1856 to 1869. In 1863, Mitty caught an infectious disease at school and transmitted it to her small sisters, Millie and Jessie. All three children, ages seven, four, and two, died within days of each other.

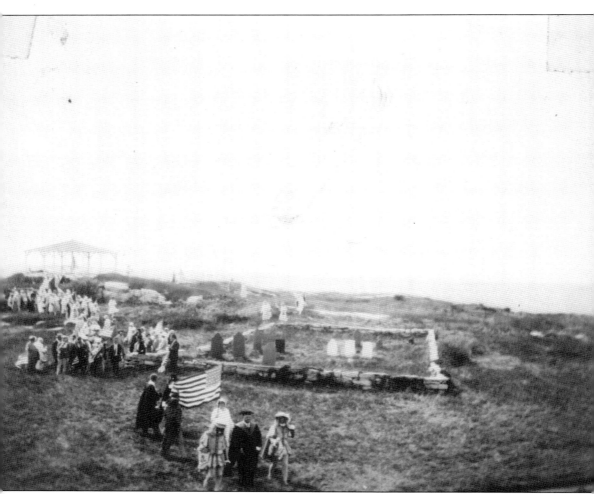

Caswell cemetery, located near the summerhouse on Star Island, is one of several surviving cemeteries on the islands. A more ancient graveyard, now overgrown and indiscernible, lies beyond the village toward the southern portion of Star Island. Early visitors described it as roughly, though reverently, marked with granite head and foot stones. Arriving in the early 1700s, the Caswells are said to have reigned over Star Island, much as the Laightons did over Appledore Island and the Haleys over Smuttynose Island. They operated boarding houses and the general store and owned much of the property and livestock. However, as did most residents of Gosport, the Caswells sold their property and relocated to the mainland in the 1870s. An archaeological study of the burial ground determined that it was recycled, the present graves placed over older graves dating back to 1700. Today the stones are askew and barely readable. This image of a pageant performed during a conference was taken around 1920. Leading the procession, donning the cap and gown, is Carl Wetherell, president of the Isles of Shoals Summer Meetings Association from 1918 to 1922.

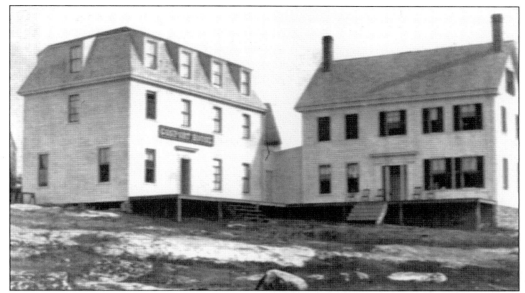

The images on this page were recorded in 1871. When the popular resort Appledore House opened in the mid-19th century, it was apparent that accommodations for the overflow of guests were needed. The Gosport House (left) was an early boarding house on Star Island owned and operated by Origen Caswell.

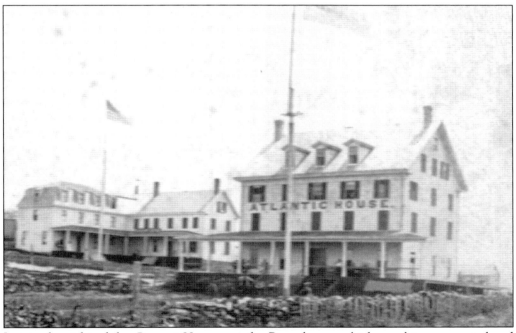

Just to the right of the Gosport House was the Berry house, which was later connected and incorporated into the small hotel. Built in 1856, the Atlantic House was known for its good home cooking. It was owned and operated by Origen's brother, Lemuel B. Caswell. Burned in 1866, it was rebuilt it in 1869. Today all of the buildings seen here are part of the second Oceanic Hotel.

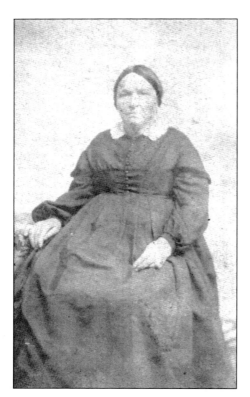

Sally Berry Caswell, or Aunt Sally, as she was known, and her husband, Joseph, were proprietors of a modest boarding house on Star Island in the first half of the 19th century. Joseph inherited much property from his father, John Caswell, patriarch of the Caswell dynasty. Aunt Sally was known for her hearty home cooking and baking.

Lemuel B. Caswell, proprietor of the Atlantic House, deeply regretted selling his property to John Poor in 1872. Later as landlord of the Hontvet house on Smuttynose Island, Caswell sold little pieces of bloodstained wood to souvenir hunters from the mainland, much to the dismay of his tenants.

Origen Caswell was respected as one of the finest citizens of Gosport. In addition to proprietor of the Gosport House, he was a representative and clerk for the town. He was to marry Star Island schoolteacher Christine Haley but contracted smallpox and died a premature death.

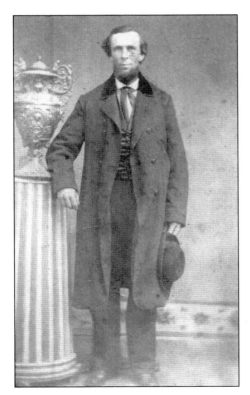

Haley was so well regarded by the Caswell family that they shared an equal portion of Origen's estate with her. Years later, Haley became engaged to another man, a judge from New York City, and asked the Caswells for their blessing, which they readily gave. Origen and Lemuel's brother, Andrew J. Caswell, is seen here in a wedding suit made of satin and "a very fine broadcloth."

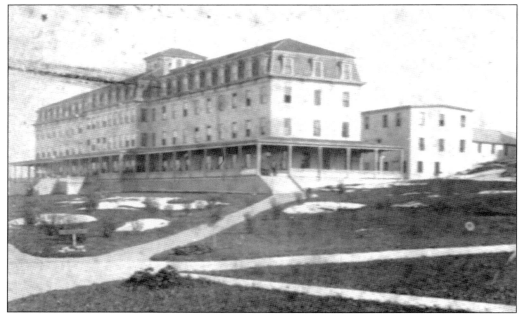

In 1873, John Poor, of Stickney and Poor's Spices, built the first Oceanic Hotel, seen here prior to 1875. Located close to the waterfront, the elegant structure rivaled the Appledore House. It had operated only a few short seasons when it caught fire and burned to the ground. The building just behind the hotel is probably the original Downs cottage, as its location was said to be the closest building in proximity to the hotel.

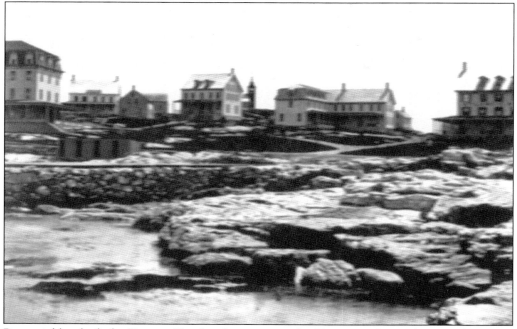

Poor quickly rebuilt the Oceanic Hotel, utilizing existing buildings, seen here. The second Oceanic Hotel is comprised of the Atlantic House (right) at its west end, the Gosport House at its east end, a Caswell house in the rear, and a central addition joining the entire group of buildings.

The Downs cottage was built by John Bragg Downs. Damaged in the Oceanic Hotel fire in 1875, the family rebuilt it in 1876. Downs was annoyed when Poor erected the monstrous hotel directly in front of his home, blocking the expansive and breathtaking views of the sea he had enjoyed his entire life.

Refusing to sell to Poor, Downs was the last resident of the town of Gosport. His wife, Martha, was the midwife for the islands in the mid-19th century. His grandson John William Downs, shown here, son of natives Ephraim Downs and Mary Caswell, was born in 1870. In his autobiography, *Sprays of Salt*, he offers a first hand account of historical events and everyday life at the Isles of Shoals.

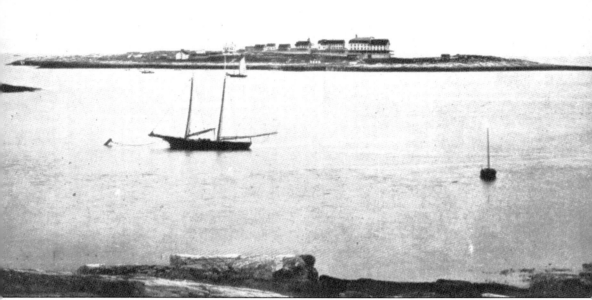

This is a view of Star Island before the breakwater was built in 1913, connecting it to Cedar Island and providing a good safe harbor. Taken from Appledore Island, the tip of Malaga Island is just visible to the left. With the exception of a few buildings, the present view is much the same. A visit to Star Island today evokes a sense of timelessness. The sights, sounds, and smells transport island guests back to a time when it was inhabited with the stoic fisherfolk that made these rocks their home. But, in the words of the "real old Shoalers," all the residents of Gosport have "gone to America."

Two
A Lighthouse and a Lifesaving Station

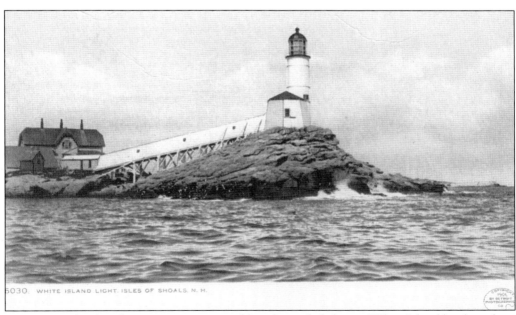

As signature landmarks go, it is near impossible to beat a lighthouse. White Island has been host to such a structure since 1821, when the federal government constructed a stone tower, giving it an atypical red, white, and blue flash. The light was a welcome sight to the fishermen who had been working the Isles of Shoals for decades, a shining beacon through the darkness that guided them as they fought their way home during storms. Yet the lighthouse had troubles with those same storms as well. One particular gale in 1839 forced the keeper, Thomas Laighton, to bring his cow into the kitchen for safekeeping.

Laighton, who moved to the island as he fled from the mainland, supposedly to escape the cutthroat world of American politics, accepted the post of lighthouse keeper in 1839. His daughter Celia remembered standing and staring in fascination of the lighthouse as she arrived on the island as a child: "It was at sunset in autumn that we were set ashore on that loneliest, lovely rock, where the lighthouse looked down on us like some tall, black-capped giant, and filled me with awe and wonder."

American lighthouses were built primarily to help guide ships into ports, an utter necessity for a maritime country that both moves trade goods along its own coasts and accepts them from ships sailing from international ports. But lighthouses immediately develop a second persona as lifesavers. Sometimes lifesaving comes as a result of the darkness piercing beams; in other instances, the result comes from human contact.

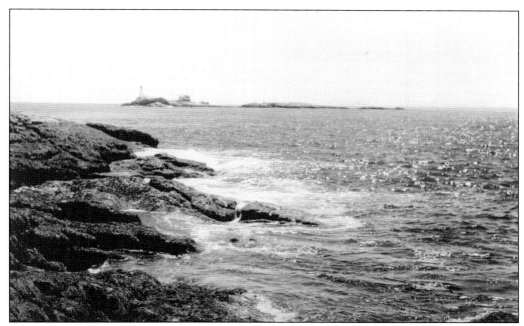

Rocky coastlines like those of Maine, New Hampshire, and parts of Massachusetts have always been treacherous for masters of ships. Temporary keeper John Bragg Downs found out while on duty in the 1850s that sometimes that danger can bring tragedy right to a light keeper's doorstep.

A sharp knock at the door one night began a chain of events that turned Downs into a local lifesaving hero. A bloody sailor, beaten up by the rocks when his ship slammed ashore, informed Downs that the rest of the crew of his brig was in peril following the wreck. Downs followed him, lowered a line to the men, and then scaled the cliff to aid them all to safety. He saved every man from the doomed vessel.

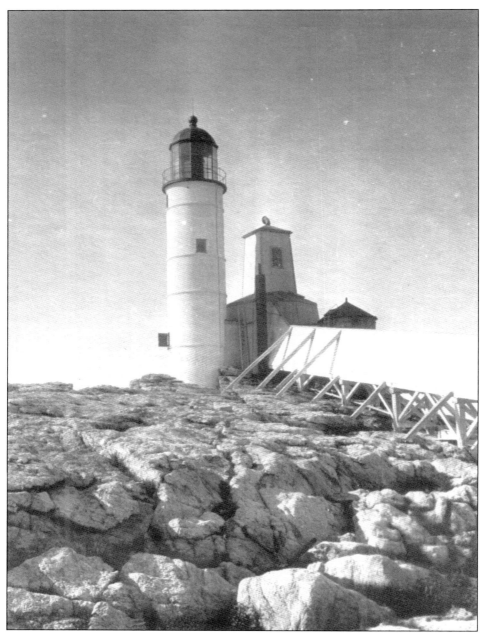

Yet not all life at White Island Lighthouse was as dramatic as that fateful night. Romantic idealists today see lighthouses as the ultimate getaway sight in the pursuit of serenity and escapism. And while an early lighthouse keeper's job was anything but cushy, when one considers the manual labor involved with carrying buckets of oil up the tower steps to keep the lights burning through all kinds of weather, in some instances, those idealists were onto something. Seclusion suited some families. Oscar Laighton, in his *Ninety Years at the Isles of Shoals*, wrote of his memories of being brought up at White Island Light. "Many people have said, 'You must have been very lonely at the Light.' They did not know that where our mother dwelt there was happiness also. I am sure no family was ever more united and contented than the Laightons on White Island."

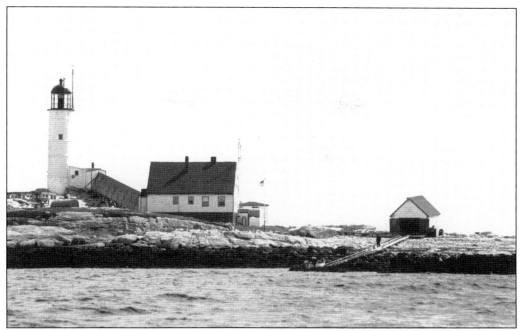

In recent years, the new White Island Lighthouse (constructed in 1859 in place of the old one) has gone through a serious preservation scare. Cracks were found to be splitting the lighthouse tower in several places, in some cases allowing one to look from the inside of the tower to the world outside, through several courses of bricks. Along came a group of seventh graders, however, to the lighthouse's rescue.

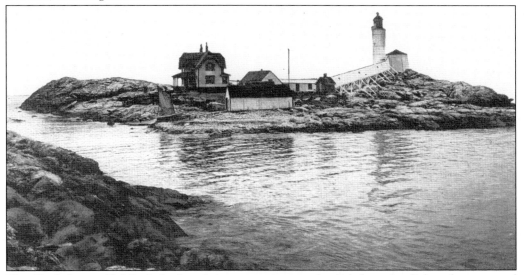

The "Lighthouse Kids" pledged to bring attention to the lighthouse's plight wherever and whenever they could. Their lobbying for the preservation of the lighthouse, which had been transferred to the New Hampshire state parks department in 1993, led to the granting of $250,000 from the Save America's Treasures fund in 2003. Two years later, the Lighthouse Kids presented the governor of New Hampshire with $110,000 and restoration began. The lighthouse has since been repaired.

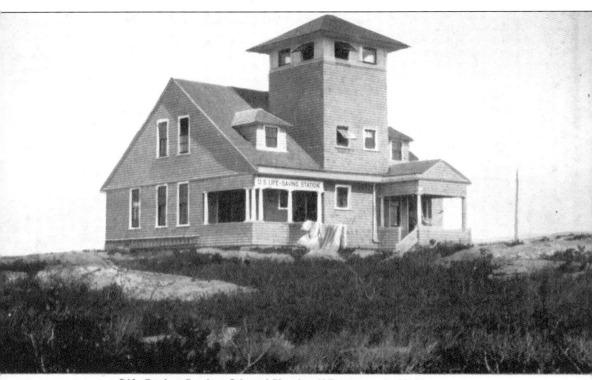

Life Saving Station, Isles of Shoals off Portsmouth, N. H.

White Island Lighthouse did not represent the only federal government presence on the Isles of Shoals. The United States Life-Saving Service began operation as a separate entity from the United States Revenue Cutter Service in 1878, tasked with saving the lives and cargo of ships in danger along the American shorelines. By 1915, the United States Life-Saving Service boasted more than 275 stations around the country, including one on Appledore Island. The Isles of Shoals Life-Saving Station, which opened in 1910, was a unique design, with a pronounced, oversized watchtower spacious enough for several men to be in at the same time. This comfort factor proved to be a problem for the station's keepers, though, as they often found their "surfmen" asleep on duty.

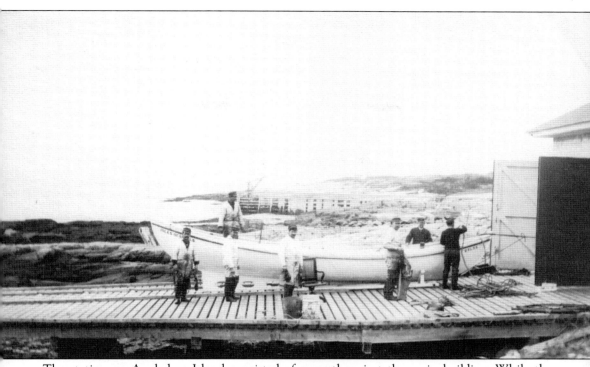

The station on Appledore Island consisted of more than just the main building. While the station's prominent position atop the island offered fantastic 360-degree views of nearby waters, including easy viewing of Maine's Mount Agamenticus to the north, it precluded easy access to the water from that position by boat. The United States Life-Saving Service solved this problem by building a separate boathouse by the saltwater swimming pool on the southwest corner of the island. The lifesavers, seven surfmen plus a keeper, drilled, patrolled, and drilled some more. Although their services were called upon several times throughout the early years, mostly they served as a marine towing agency for disabled power boats. Their most memorable service may have come in 1914 when they helped put out the fire that claimed the Appledore House.

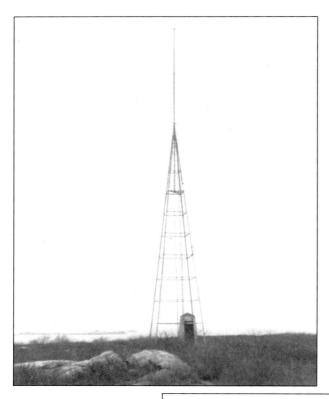

The station served through World War II, and then was deemed no longer needed by the Coast Guard (the United States Life-Saving Service and the United States Revenue Cutter Service merged in 1915 to form the Coast Guard) in 1954. When the General Services Administration took control of the building for disposal or redistribution, numerous other structures came with it, including this steel signal tower.

The lifesavers drilled with the Lyle gun and breeches buoy system, known as the "beach apparatus," twice a week. To do so, the crew needed a "wreck pole," a mock ship's mast from which to run the lines and practice the procedures that would be used in a real emergency. The extant coastal artillery observation tower stands in the background.

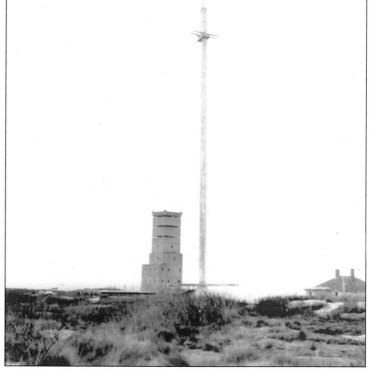

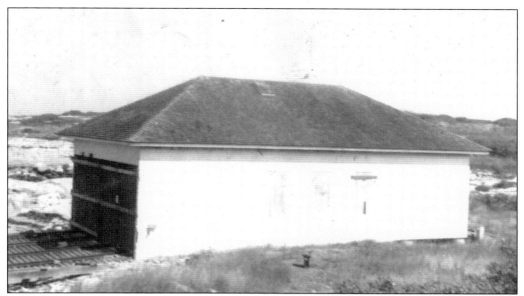

The boathouse had served as a repair shop for the service's new motorized boats more than it did as a launching site for those same boats. The boathouse no longer stands today, yet one artifact from its historic presence remains. The winch motor used to pull the boats up the boat ramp into the boathouse was simply too tough to remove when the building came down, so it remains where it has always stood, just above the swimming pool.

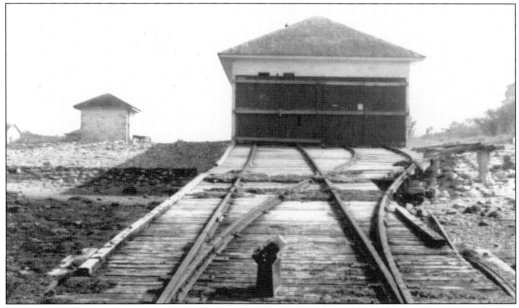

The marine railway that once launched and brought back home the United States Life-Saving Service and Coast Guard's lifeboats was completed in 1921. Railways like this one allowed the lifesavers an alternative to leaving their boats exposed to the elements on a mooring during a storm and allowed for the development of heavy, motor-driven boats. Prior to the beginning of the 20th century, practically all lifeboats were oar-powered, and launched by manpower, with the aid of the occasional horse.

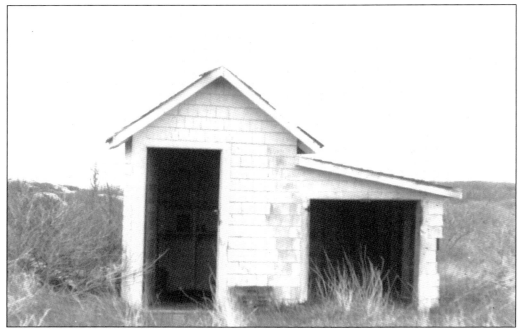

Another remnant of the old station included this tool shed in the rear of the station. The lifesavers drilled five days a week, with the beach apparatus on Mondays and Wednesdays, with their capsized lifeboat on Tuesdays, with signal flags on Wednesdays, and practicing with artificial resuscitation on Fridays. Many of the tools they needed to do their work would have been kept in this building.

This small shelter, which can also be seen in the background on the picture of the marine railway on page 31, would have offered the lifesavers a place to get out of the wind and elements while on patrol at night. The lifesavers patrolled the American shorelines for 10 months out of the year, 7 days a week, no matter what the weather offered.

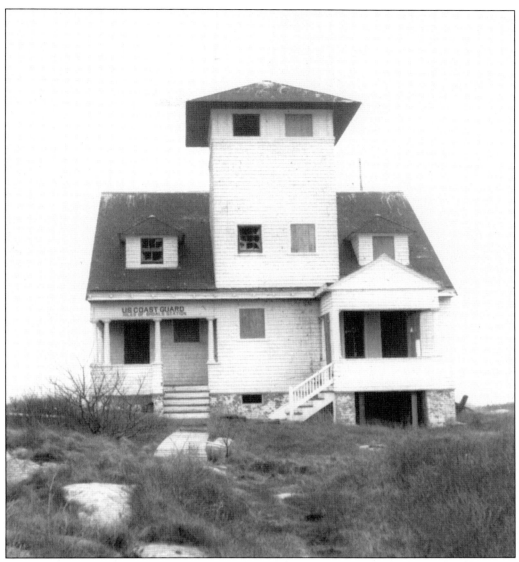

The closing of the station led to the auctioning of the property in 1954. The General Services Administration sent out notices to 1,300 people and post offices, accepting the winning bid from Howard A. Dodge of Washington, D.C., a pledge of $2,600 for the main building and its attendant outbuildings. Dodge found the station to be vandalized and in serious disrepair when he visited Appledore later that year, however, and gave up all rights to the station. The government pulled the station back from dispersal in 1958 and did nothing with it until 1967. In that year finally, they decided to return the land to the original owner, as outlined in the original deed of 1908, offering it back to the descendants of the original owners for $50. Having paid the Laightons $650 for the land and having sunk $20,000 into it over the next half century, the government sold the station to the Star Island Corporation in 1967 for $50. Fully restored today, the Isles of Shoals Life-Saving Station serves as a dormitory for the Shoals Marine Lab.

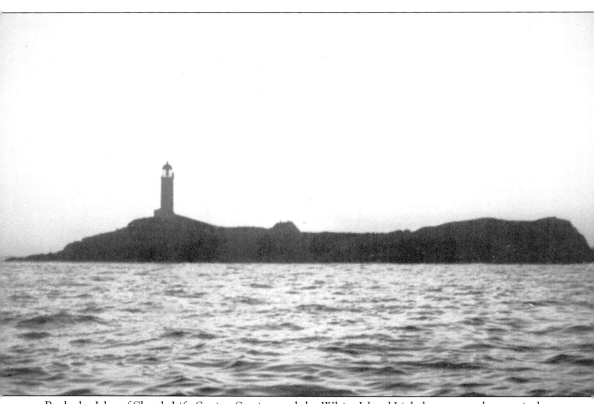

Both the Isles of Shoals Life-Saving Station and the White Island Lighthouse stand as reminders of days of yore, when America's economy depended strongly on a large number of what would today be considered small ships that moved cargo from port to port, raw materials from one place for processing in another. Lighthouses guided the way and lifesaving crews responded when ships got in trouble on the sea. Ironically both stations today serve as research facilities for natural sciences. The lifesaving station, as heretofore stated, is operated by the Shoals Marine Lab. The keeper's quarters at the lighthouse has recently been home to Audubon Society of New Hampshire researchers helping to save endangered terns on Seavey Island. But the original purpose remains. Today, powered by modern lighthouse technology, White Island Lighthouse shines its beam to three states, and for miles out to sea, to warn all mariners of the dangers of the rocky Isles of Shoals.

Three
Appledore Island

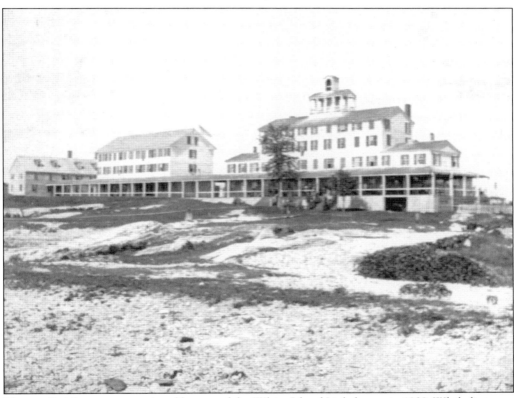

Thomas Laighton was appointed keeper of the White Island Lighthouse in 1839. While living at the Isles of Shoals, he acquired Hog, Smuttynose, Malaga, and Cedar Islands. He also acquired the Haley's Mid-Ocean House of Entertainment on Smuttynose Island. Laighton had an idea for a bigger inn and with the financial help of Levi Thaxter, a well-connected young man, he changed the name of Hog Island to Appledore Island and built the Appledore House. This hotel opened on June 15, 1848, and is the building to the right in this photograph.

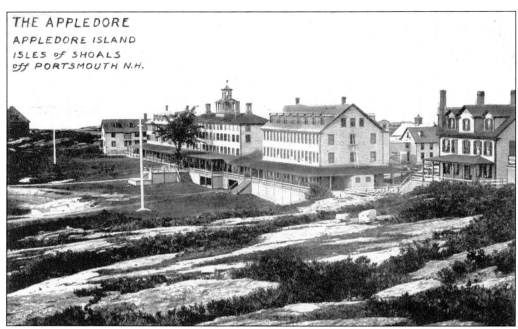

The Appledore House quickly became a popular resort and many buildings were added. The building to the left of the original building was built in 1859 and contained 40 guest rooms and a dance hall, known as the North Wing. Between 1861 and 1870, an additional building and a 500-seat dining room were added to the right of the original building.

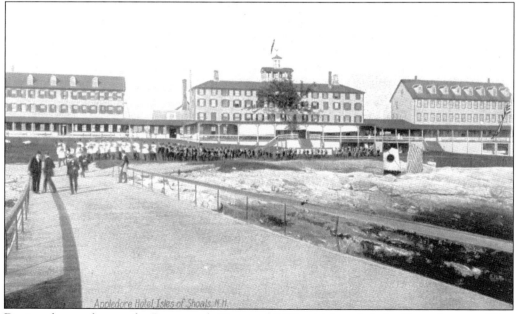

During the conference for Portsmouth Treaty of 1905, which ended the Russo-Japanese War, Oscar Laighton invited the delegates to Appledore Island. This postcard shows the reception for the delegates in front of the hotel with a brass band. Note the Japanese flag on the rocks in the foreground.

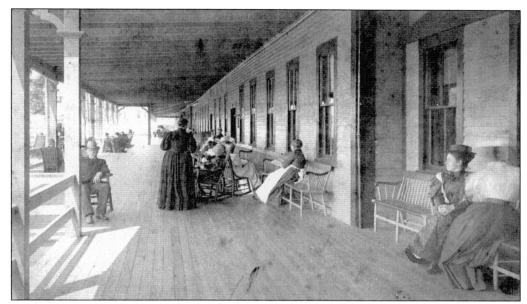

Of all the activities that took place at the hotels at the Isles of Shoals, the tradition of sitting in a rocking chair on the long piazzas seems to have lasted from the beginning to the present day. This scene is the piazza at Appledore House in the beginning of the 20th century. This piazza was over 500 feet long and connected some of the close cottages both to the north and south.

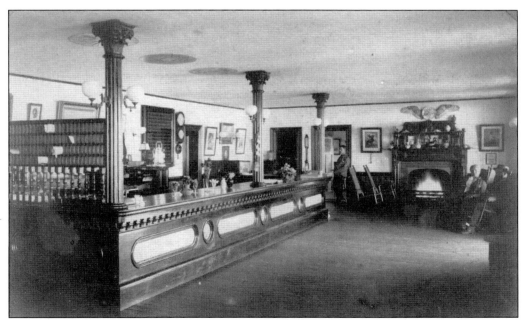

The lobby of the Appledore House was another place for guests to gather. Note the barometer on the back wall. Some of the decorations reflect Celia Thaxter's taste. She most likely collected the owl wings that are hung over the fireplace. With her interest in birds, she later became a member of the Audubon Society. The flowers on the desk are also her touch. The mailbox at the end of the desk enables guests to get their own mail.

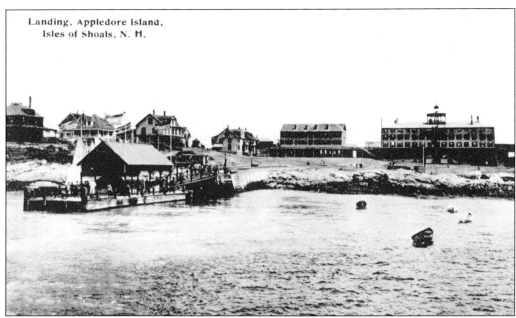

After Star Island built a pier in 1873, Appledore Island felt pressure to have better access for island landing for its guests. Oscar Laighton wrote, "the moment the season was over we started work on our landing by building a cribwork pier of red oak logs, running as far out below low watermark as possible. This was filled with thousands of tons of stones . . . The winter following we had a big flat boat built." The boat was fastened, according to Laighton, "by ship chains to the ledges on either side of the cove, and the flat boat connected (to the pier) by a bridge."

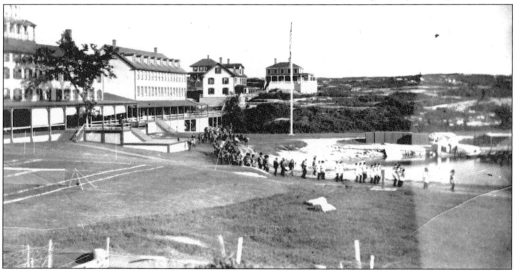

It was not only the Unitarians that came as a group to the big hotels at the Isles of Shoals. This photograph is labeled "Masons on Appledore." The photograph was taken from Celia Thaxter's garden. The private cottages in the background are the south cottages and survived the fire of 1914. It was a Massachusetts man, Mr. Hart, who first entered into an agreement to build a private cottage. The agreement was for 20 years. Soon others built cottages until there were nine of them.

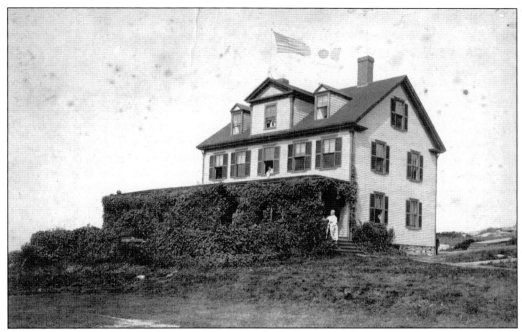

Thaxter is standing on the steps of her Appledore Island cottage. One can view others inside and outside of the cottage as well, including a male figure by the right rear corner. Note the birdhouse over the porch to the right. This is where the artists, writers, and musicians attended Thaxter's salon each summer. This intellectual gathering was thought to equal those held in Concord, Massachusetts.

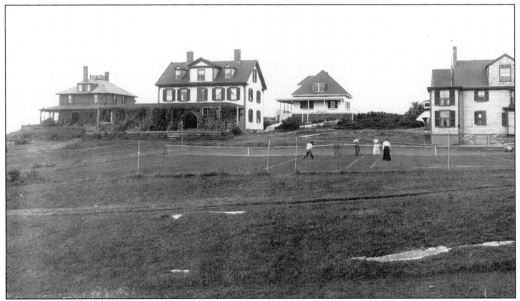

Behind the tennis courts, the cottages are, from left to right, the Laighton's (built 1881), Thaxter's (1864), a private cottage, and North Cottage (about 1848). In addition to tennis, there were many activities that the hotel offered, such as billiards, bowling, a ballroom, band music, theater, chapel, a saltwater swimming pool and, of course, the stars and the sea.

In 1909, after the hotel was foreclosed, the Appledore Land Building Company was organized. A part of Appledore Island was subdivided into lots for summer homes. There were 585 lots altogether; of these, only 61 sold. Abbie W. Johnson, a cousin of the Laightons, bought several lots on the south of the island. She had Oscar Laighton build this stone house in 1910.

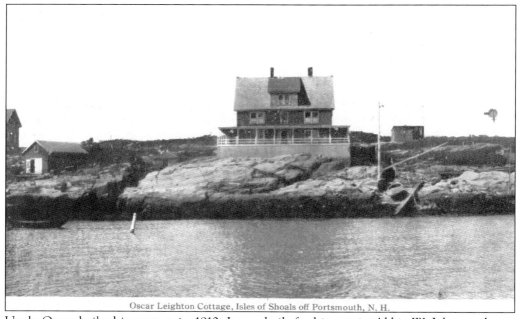

Oscar Leighton Cottage, Isles of Shoals off Portsmouth, N. H.

Uncle Oscar built this cottage in 1910. It was built for his cousin Abbie W. Johnson, but is remembered as Uncle Oscar's cottage. At the time the cottage was built, the hotel was in foreclosure and parcels of land were being sold to raise money. Soon the Appledore House would be lost due to a fire, in 1914, but this cottage would survive.

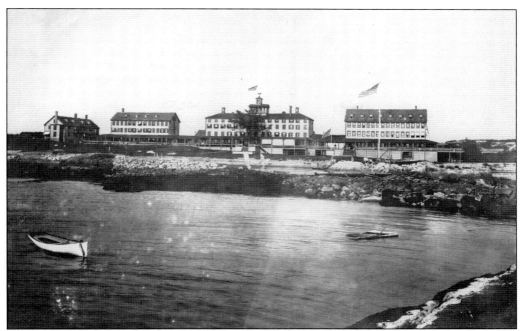

This photograph shows the main buildings of the Appledore House, as well as North Cottage, as they appeared in the 1870s and until they burned in 1914. When the hotel was opened in 1848, it became a great success. In many ways, it was a leader in the summer resort business. By the 1870s, the sea, good management, and a gathering place for the famous were not enough to prevent new competing resort hotels from making a dent in the hotel's business. The hotel began to have financial concerns.

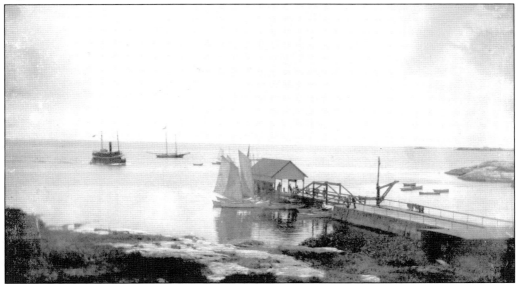

This photograph seems to depict one of the last boat runs of the day. The steamer looks like the *Major* (also known as *Oceanic*), which ran from 1873 to 1886. The schooner in the background, as well as the sailboats at the pier, are no doubt island boats. There was a cheer for the guests leaving Appledore: "AP-PLE-DOR-eee-Appledore!"

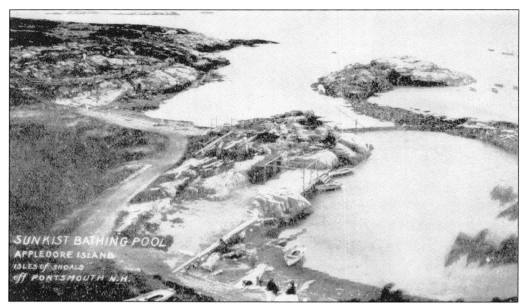

The swimming pool at Appledore Island was an early improvement by the Laightons, of which they were justly proud. An advertisement read, "The Bathing Pool at Appledore Island affords excellent bathing; it is shut off from the outer sea, is free from undertow, and the water is always agreeably warm. The incoming tide fills the pool to a depth that renders it perfectly safe for the use of children, for rowing, sailing and bathing, and a careful attendant is in charge."

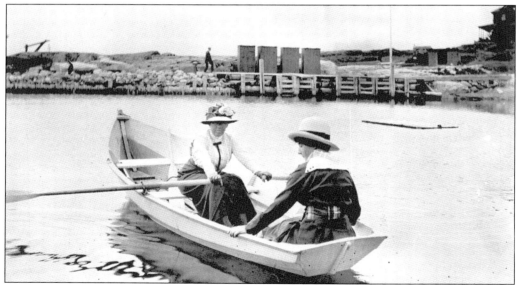

A ride in a rowboat, a band concert on the piazza, lobster dinner, and dancing may have been a typical day for these ladies at Appledore Island in the hotel period. In the background are the men's bathhouses; on the other side of the swimming pool were the women's bathhouses. The crane on the pier can also be seen. The attendant for the pool was a college student who taught swimming, kept the pool clean, and oversaw any fight that took place amongst the children.

This photograph holds the lyrical caption "Three Bells on Appledore" on its verso side. Oscar Laighton wrote, "It seemed to me that the most beautiful girls in all the world were visiting Appledore. Every summer I would fall so deeply in love, it would take me all the next winter to come to; then the returning season it would happen all over again." He also said, "Our island was a paradise for young lovers . . . Hardly a summer passes without an engagement, and one season there were five."

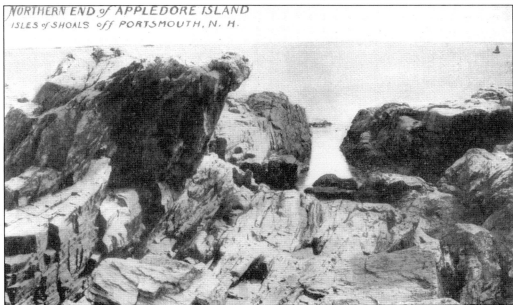

These northern headlands of Appledore Island were a favorite subject of Childe Hassam and other artists of the 19th century who painted at the Isles of Shoals. Long before and long after the paintings of the foaming water and the hard rocks were finished, the water and rocks remain the essence of Appledore Island.

Childe Hassam not only painted the rocks at Appledore Island, he and Margaret Laighton dived off them. He spent summers between the 1880s and the early 20th century at Appledore amongst Celia Thaxter's cultured friends. The pictures he painted during these summers are some of the most renowned of America's best known impressionists.

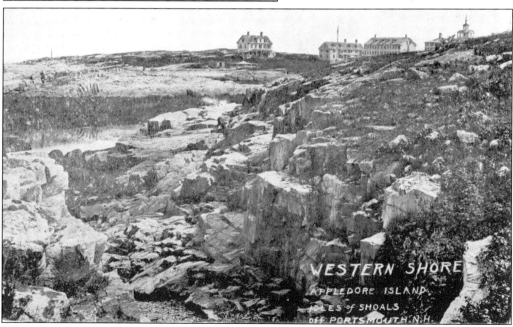

This photograph is taken from the western side of Appledore Island. The original hotel building can be seen with its cupola and the north wing to its left. The building at a right angle is North Cottage. To the left is Thaxter's cottage at the time when her folks were living there.

Four

CELIA THAXTER'S FRIENDS AND FAMILY

Born at 50 Daniels Street in Portsmouth, the second house on the left in this image, Celia Laighton Thaxter (1835–1894) was by far the most famed inhabitant of the Isles of Shoals. Her father, Thomas B. Laighton, moved the family to White Island in 1839 and assumed the position of lighthouse keeper. Intending to help revive the fishing industry at the Isles of Shoals, Laighton had purchased four of the nine islands including Smuttynose, Hog (later renamed Appledore), Malaga, and Cedar. In the 1840s, the family moved from White Island to Smuttynose Island and operated a small hotel and boarding house called the Mid-Ocean House of Entertainment. Discovering a flair for the hospitality business, the Laightons opened the Appledore House on Appledore Island in 1848, and its reputation as a resort quickly grew.

45

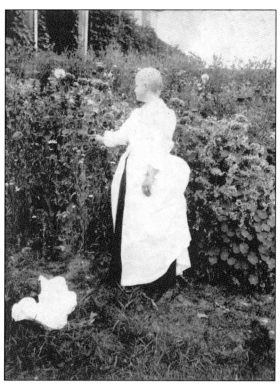

At 16, Celia married her childhood tutor, Harvard graduate Levi Thaxter. Through Levi, Celia was introduced to Boston's literary elite. Included in the couple's circle of friends were names like Charles Dickens and Nathaniel Hawthorne. Inheriting her parents' talents for hosting and her husband's entourage, it was ultimately Celia, seen here in her famed garden on Appledore Island in July 1889, to which these and other artists of the day flocked.

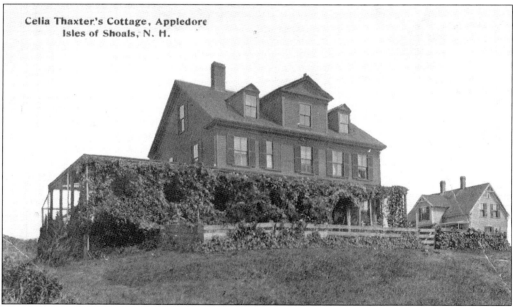

A popular haven for guests, Celia's cottage on Appledore Island was described by one visitor as a wonderful blend of gardens, the best music, loveliest art, finest poetry readings, and intellectual banter. It was considered an honor to be an invited guest at Celia's cottage and participate in one of her salon gatherings where some of the most revered artists, musicians, and writers of the era worked and played.

An abundance of hops and wild cucumber vines covered Celia's porch and entryway, leaving portals through which one could watch the comings and goings of sailing and fishing vessels and steamships and their passengers. This image peeks out through the west end of the trellised veranda, a view that artist Childe Hassam captured on canvas. Imagine the leisurely summer hours spent musing on Celia's porch with the intellectuals of the day.

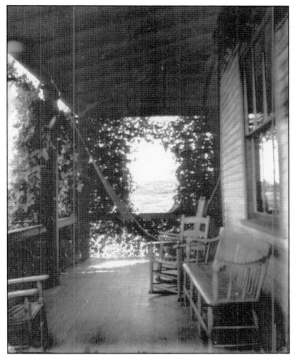

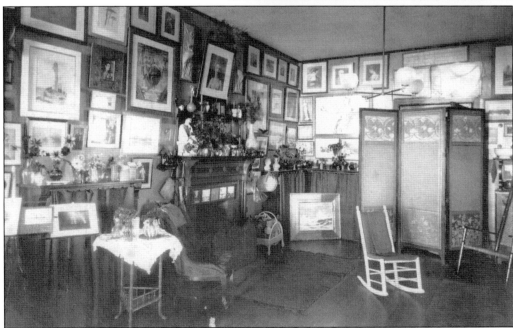

The parlor in Celia's cottage, a veritable Shangri-la for those admiring the arts of all sorts, was the nucleus of the artist colony that Appledore Island was destined to become. Her parlor was crammed, almost to the point of clutter, with paintings and other objects of fine art. Note the flower-filled vases perched upon every available shelf space, lovingly arranged each morning with flowers gathered from her renowned garden.

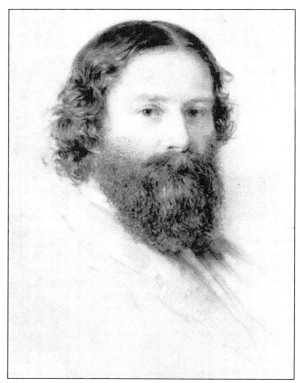

James Russell Lowell, first editor of the *Atlantic Monthly*, is credited with launching Celia Thaxter into literary fame when he published her first poem, "Landlocked," in 1861. Thaxter was kneading bread in her kitchen, longing for her island home, when she scribbled it on a piece of grocery paper. An anonymous friend, perhaps her husband Levi, submitted it to Lowell, astonishing an unsuspecting Celia when she first saw it in print.

Son of a Portsmouth shipmaster lost at sea, James T. Fields became an exceptionally gifted and influential publisher. Rising to senior partner in the prominent Boston firm Tichnor and Fields, he published the works of the most revered literary greats of the period. As powerful editor of the *Atlantic Monthly*, Fields once requested that Thaxter revise her poem "Seaward," a request to which she graciously declined to acquiesce.

Annie Adams, daughter of prominent Boston physician Zabdiel Boylston Adams, married distinguished publisher Fields at age 20, his junior by 17 years. As is evidenced in the book *Letters of Celia Thaxter*, Adams remained a constant source of support for Thaxter through some of the best and the worst times of her life.

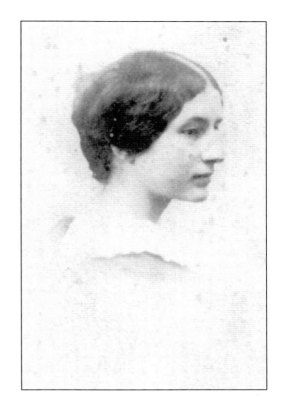

Son of a rural Massachusetts Quaker farmer, John Greenleaf Whittier's limited schooling included one year at the prestigious Haverhill Academy. However, this did nothing to preclude a successful career in both politics and literature. Although some biographers intimate a romantic interest existed between Thaxter and Whittier, there is some evidence that the reason for his lifelong bachelorhood stems from the loss of his first and foremost love, Mary Emerson Smith.

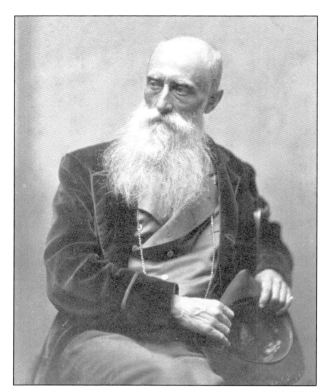

Artist William Morris Hunt tragically lost his life on Appledore Island when he drowned in the small reservoir beyond Celia Thaxter's cottage. Some feared that recent depression had driven him to suicide. Ironically one of his paintings depicted a family steaming toward the Isles of Shoals titled *The Promised Land: Ferry to Appledore*. Perhaps he, like the family portrayed in his painting, felt Appledore Island was his promised land.

Levi Thaxter's cousin Ellen Robbins, was one of several artists fortunate enough to have their own studio on Appledore Island. Other painters that found inspiration there included Childe Hassam, Ross Turner, J. Appleton Brown, and Olaf Brauner. Celia, an artist in her own right, spent many hours capturing the abundant nature which surrounded her on Appledore Island on china, book leafs, and canvas.

Two more notables among Celia's circle of friends and visitors were authors Henry Wadsworth Longfellow, shown here, and Nathaniel Hawthorne. Hawthorne arrived at Appledore Island with a letter of introduction from his friend, Franklin Pierce. Pierce was shortly to become president of the United States, and Hawthorne intimated that this influential letter was surely what landed him some of the best accommodations at the hotel.

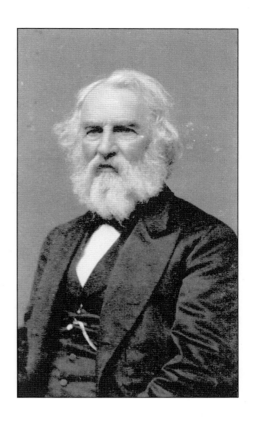

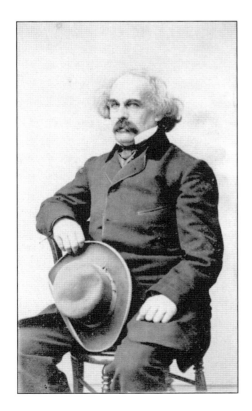

In his journal, Hawthorne relates many interesting tales about his visit to the Isles of Shoals. One such tale is of a shark sighting in the bay west of the Appledore House. He described the shark as 8 to 10 feet in length and so close to shore as to be almost aground. Oscar Laighton fired at it twice with a gun. Apparently he missed, but the shark disappeared from the bay, much to the relief of the guests.

Musician John Knowles Paine intended to visit Appledore Island for one week and ended up staying for six. According to Annie Fields, it was Paine's influence that awakened Celia Thaxter to the pleasures of music. For hours he would play her favorite, Beethoven sonatas. Celia's niece Barbara Durant later recalled having a bit of fun by telling unsuspecting tourists that the portrait of Beethoven hanging in the parlor was Thaxter's husband, Levi.

When a guest at Appledore Island, piano virtuoso William Mason could be heard playing Chopin and Schumann on the grand piano in Thaxter's beloved parlor each morning at 11:00 a.m. The captivating sounds wafted out the window and drifted down to guests bathing in the swimming pool. His father, Lowell Mason, was a pioneer in public school music education in America and the founder of the Boston Academy of Music.

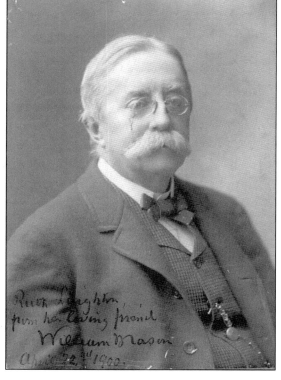

German musical composer and violinist Julius Eichberg, was a welcome addition to Thaxter's salon circle. In a correspondence to friend Elizabeth Pierce, she writes that Eichberg had set her poem titled "Forebodings" to music, proudly adding that he claimed it to be the finest piece he had ever composed. Eichberg founded the Boston Conservatory of Music in 1867.

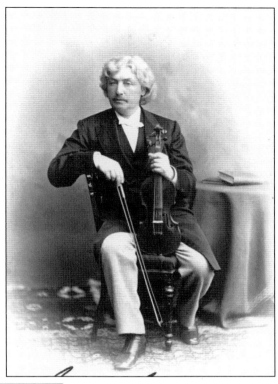

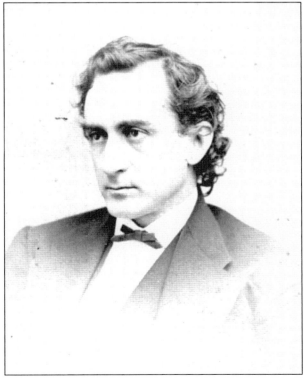

Well-known 19th-century actor Edwin Thomas Booth was another of Thaxter's friends and visitors to Appledore Island. Ironically, prior to his brother John Wilkes Booth's assassination of Pres. Abraham Lincoln, Edwin had saved Lincoln's son Robert from what could have been a fatal accident when he caught Robert by the collar as he nearly tumbled onto the tracks near a moving train.

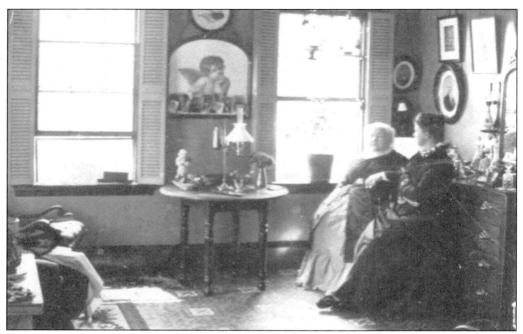

Celia Thaxter was very close to her mother, Eliza Rhymes Laighton. In this image, probably from the 1870s, Eliza is seated by the window with her daughter nearby. Eliza, unquestionably the matriarch of the Laighton family, was revered by her husband and children. Despite the fact that she intimated her longing to spend time with her daughter and grandchildren in a letter to Thaxter, Eliza rarely left her husband's side.

Thaxter had two younger brothers, Oscar and Cedric, shown here, with whom she remained quite close her entire life. An older sister named Helen had survived only 11 months. After their father's death in 1866, Oscar and Cedric took over the business operations of the Appledore House, while Thaxter acted as hostess. Whereas Oscar remained forever a bachelor, Cedric married Julia Stowell of Cambridge in 1881.

Celia and Levi Thaxter had three sons, Karl, John, and Roland. The couple eventually spent much of their time apart, fragmenting the family. Levi often traveled with the younger boys or resided on the mainland, while Celia and a somewhat mentally and physically deficient Karl stayed at Appledore. Levi is seen here with the youngest son, Roland. Inheriting both parents' love of nature, Roland became a professor of botany at Harvard University.

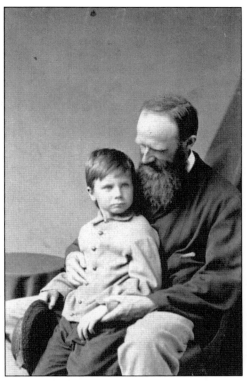

Perhaps being born in a mill house in Newburyport, Massachusetts, instilled a love of farming in Roland's brother John, who tended the family homestead in Kittery, known as Champernowne Farm. Brother Karl was an amateur inventor and photographer. All three sons are buried with their father in Cutts Cemetery at Kittery Point.

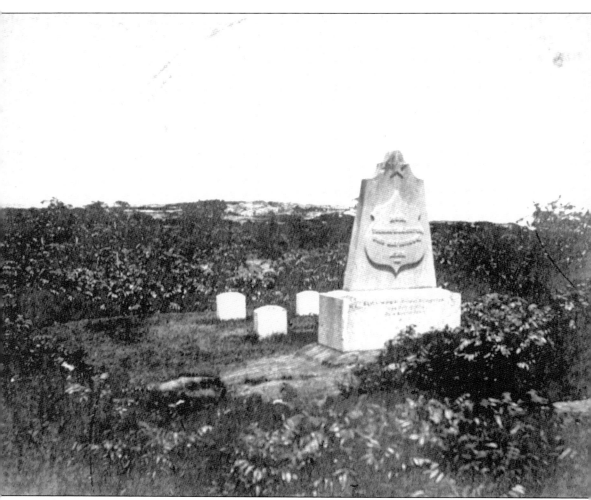

Almost as testament to their disconnected married life, the Thaxters lie separately in death. Today those coming to Appledore Island to tour the recreation of Celia's famous garden often take the short walk up the trail to visit the Laighton family cemetery. There, Thomas and Eliza, Celia, Oscar, and Cedric all slumber peacefully and eternally on the island that was their beloved home.

Five

CONFERENCES ON STAR ISLAND

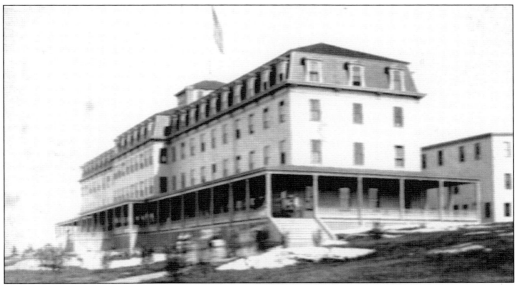

By the end of the 19th century, plan B for the Isles of Shoals was failing. Plan A, to run the islands as an independent community with an economy based on fishing, had long since gone by the boards. Plan B, summer tourist destination, was running its course, but not for any reason specific to the Isles of Shoals themselves. Instead the greater forces of American history were causing changes with which the Shoalers, and the Laightons in particular, were unable to cope. For a half century, trains brought people to Portsmouth, and steamers brought visitors to the Shoals. As trains increased their reach, new and wondrous places opened up for tourist exploration. The coming of the automobile augmented the sense of independent discovery in America, and the fate of the tourism era at the Isles of Shoals was sealed. The first Oceanic Hotel, burned in 1875, symbolized the good times of plan B. What would be plan C?

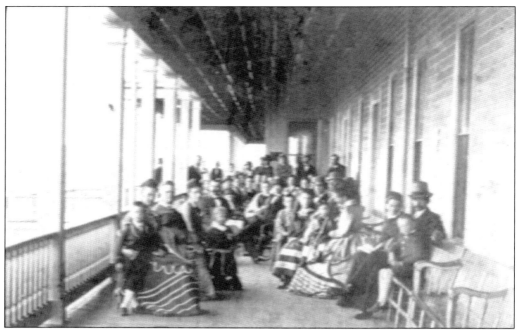

Whether or not Americans were beginning to explore the length and breadth of their country, the Isles of Shoals still offered two guarantees that many other places could not: a half century of experience catering to large crowds and the raw natural beauty of the islands. Sitting in the shade of the piazza of either the Appledore House or Oceanic Hotel on a hot, breezy summer's day would always be an attraction.

The Isles of Shoals also offered, thanks to the grand hotels, the ability to accommodate large numbers of people, given enough notice. Groups like this happy crowd, photographed around 1912, could come to the Isles of Shoals together and then relive their common memories for years to come.

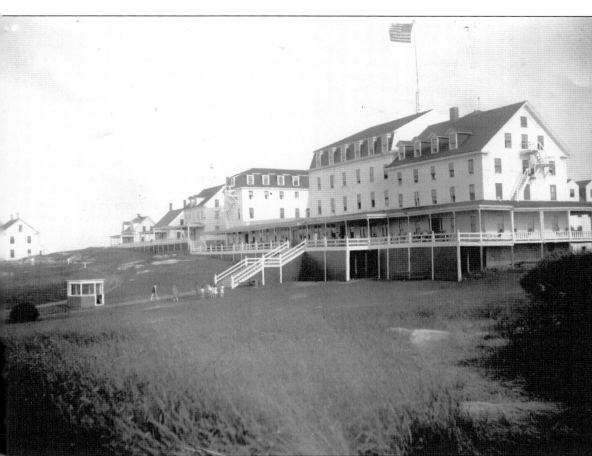

In 1896, the new Oceanic Hotel and the Appledore House stood at a crossroads. Flagging visitation called for creative thinking. In that year, a coincidental meeting took place that would alter the course of Isles of Shoals history forever. Harry Marvin, running the Oceanic Hotel for the Laightons that year, had a chance meeting with a first-time visitor to the island, Thomas Elliott, during which Elliott mentioned the notion of bringing a religious conference to the Isles of Shoals the following summer. They negotiated a price, Elliott vowed to pack both hotels "to the ridgepole," and Marvin consulted Oscar Laighton. Laighton, wary, asked, "What is a Unitarian? Are they good people? It won't do to introduce any rough element." Marvin convinced Laighton of the peaceful nature of the few Unitarians he had met, and the deal was offered: $10 per person for the week. The following year, Elliott led more than 600 people to the islands, filling both hotels to the hilt. The conference era at the Isles of Shoals had begun.

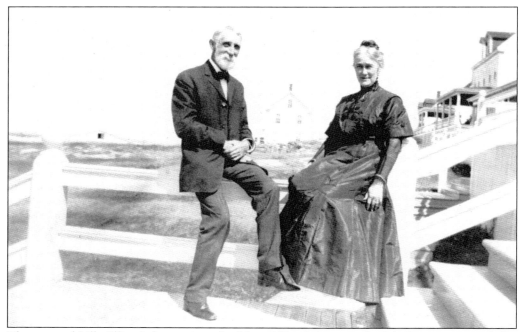

Thomas and Lilla Elliott's first visit to the Isles of Shoals happened solely for one reason. Lilla, feeling like she needed to be closer to the seashore for health purposes, told Thomas that she would rather not attend the regular religious conference at the Weirs on Lake Winnipesaukee that year. As a compromise, they visited the Isles of Shoals.

FOR SALE.
STAR ISLAND -- Isles of Shoals.

TO BE SECURED
This Property which can be no where duplicated
Must Be Bought At Once.

Lots, carefully restricted, range in value to suit the subscriber.

Plat may be seen at Unitarian Meetings or 25 Beacon St., Boston.

Full Description Given by the Agents.

THE CAMPAIGN COMMITTEE.

For the next two decades, the conferences grew in popularity. The sense of spiritual ownership of the islands became so ingrained in the attendees and organizers that a movement soon began towards the purchase of one or both islands. The decision of which island to own became easier once the Appledore House burned in 1914. In 1916, the young Star Island Corporation purchased Star Island for a total of $16,000.

Although never a religious man, Oscar Laighton, here shown with Jessie Donahue to his left and Lilla Elliott, Thomas Elliott, and Mrs. William B. Nichols, known collectively as the five founders of the Star Island conferences, Laighton found comfort among the Unitarians visiting the island. He proclaimed in his memoirs, "being with these good people fills me with a desire to walk in their footsteps, feeling sure I could not go far wrong."

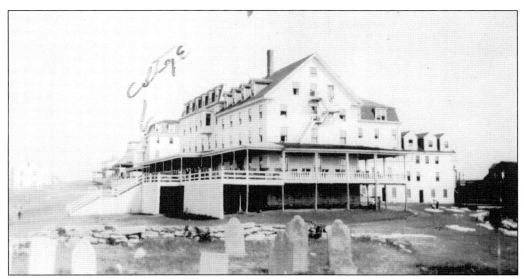

While Laighton himself provided a link between present and past for the Isles of Shoals as long as he was alive, certain physical landmarks, like the fishermen's cairns found on several of the islands and the small burial plots of the "real old shoalers," helped to foster that connection.

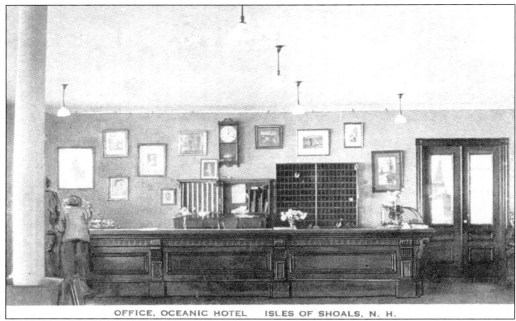

OFFICE, OCEANIC HOTEL ISLES OF SHOALS, N. H.

The "office" of the Oceanic Hotel, really just the reception desk in the lobby, was and is where all of the administration of the conferences took place. As in the Appledore House, the office was the place to get information on the upcoming events of the day, and even one's mail. Such places became social gathering spots for conference attendees, and first points of contact with the "Pelicans," the young people who arrived with the season to wait tables, clean rooms, and make things generally go smoothly on the island.

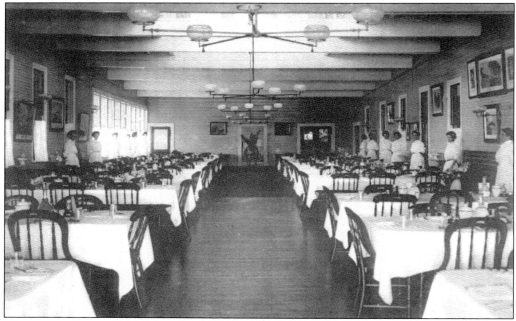

The second Oceanic Hotel has always featured a grand dining hall, a place for common meals for conference goers. Here the waitstaff stands at the ready in a formally posed picture.

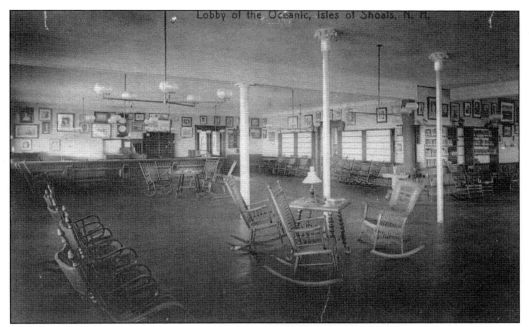

The Oceanic Hotel lobby, also spacious, offered a place to get out of either the sun or the rain, with just as congenial an atmosphere as either the piazza or the dining hall. A rocking chair feels good indoors or outdoors.

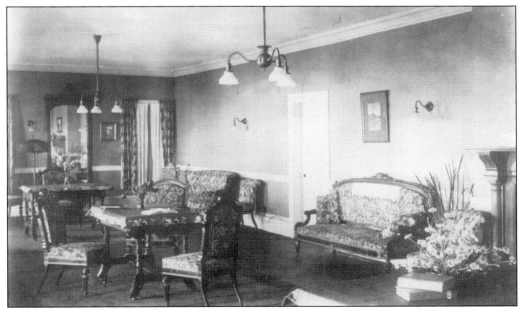

Perhaps the most famous room in the Oceanic Hotel is the Pink Parlor, a holdover from the Victorian Era, and utilized by countless visitors over the past century and a half for musical, lecture, or other small gatherings. A photograph on the wall of the parlor identifies Lewis Parkhurst as "The man who saved Star Island." Parkhurst raised the eleventh hour cash needed to buy the island before it sold to an owner of unsavory road houses.

The groups that attended the Star Island conferences did not come together haphazardly. The Isles of Shoals Summer Meetings Association (Unitarian-Universalist) formed in 1896 to sponsor the first conference, and the Congregational Summer Conference Association organized in 1914. The Star Island Corporation formed the following year. This photograph shows 10 members identified as "members of the alliance board" standing in and around the well house, a popular photography background.

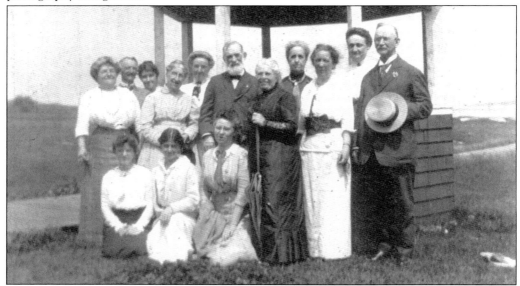

These women, representatives of a party from the Paris League, traveled from at least as far as Kingston, Massachusetts, for this July 1914 photograph. A note on the back of the photograph indicates that both Mary Drew and Helen Holmes, prominent women from that community, can be seen in the image.

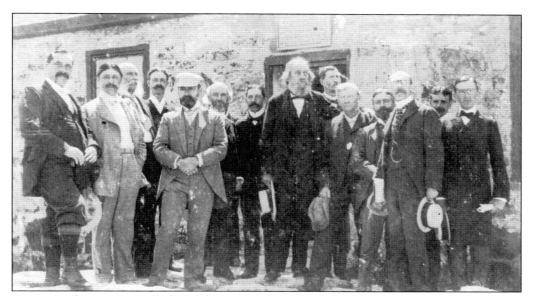

Guest preachers occasionally found their way to Star Island. Seen in this image is Edward Everett Hale, eighth from the left, a Unitarian minister who was unanimously elected chaplain of the United States Senate. The author of approximately 60 books, when asked if he prayed for the country's senators, he once replied, "No, I look at the Senators, and I pray for the country."

As much as religious instruction and camaraderie was to be enjoyed on the Isles of Shoals, conference coordinators soon saw the value in unstructured time as well. It was not that scenes like this would have been impossible under the regular conference schedules. The organizers just felt that a "No Program – Family Week" experience could be just as valuable spiritually as a rigorous schedule of prayer sessions and other religious activities.

Carl Wetherell became a fixture on Star Island, serving as president of the Isles of Shoals Meetings Association on two separate occasions, from 1918 to 1922 and from 1932 to 1938, and of the Star Island Corporation during the trying period of 1938 to 1944. During the war years, either no conferences were held, or they were held on the mainland.

Former headmaster of Proctor Academy in Andover, New Hampshire, Wetherell, certainly knew that life on the Isles of Shoals did not need to be regimented at all times. There was a time for prayer and a time for fun. Here he teaches that lesson to his wife.

Another familiar face through the years at the Star Island conferences is standing at the stern of Oscar Laighton's *Twilight*. The photograph identifies the smiling Herbert Miller as "unofficial cheerleader and entertainer for Star Island conferences."

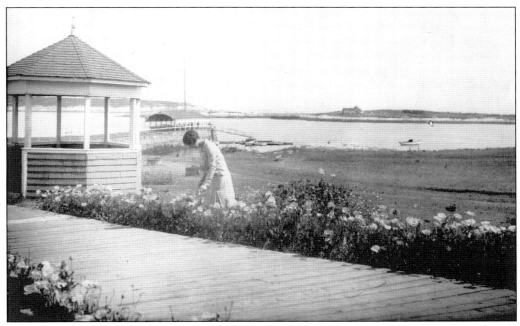

One simple action transformed a desk clerk that worked on the island for a little over a decade into the legendary "Miss Tulip" of Star Island. Her move to prune and take care of the flowers along the path to the dock, captured on film and later painted, elegantly symbolized the beauty of summer on the Isles of Shoals during the 1930s and 1940s.

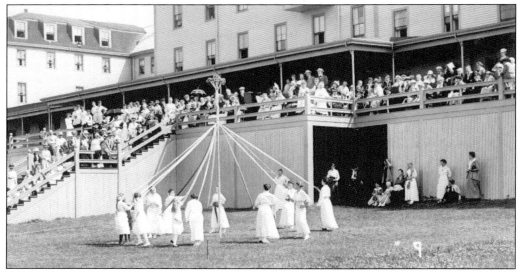

Although born of pagan roots, a maypole celebration was certainly an activity that could be seen on Star Island, as shown here in the summer of 1916. Maypole celebrations evolved in Germanic countries over the years and are still facets of religious ceremonies among Swedish communities in America today.

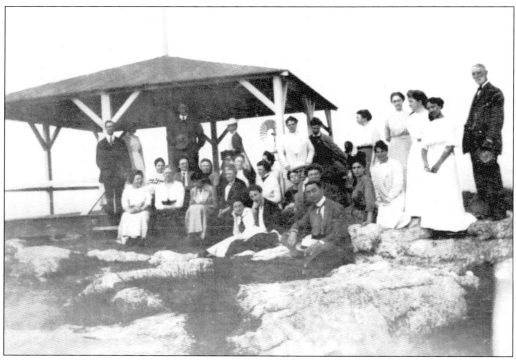

The summerhouse provided yet another convenient gathering spot for conference attendees. Built on the spot of Fort Star, the summerhouse, an open pavilion on the western side of the island and therefore overlooking the mainland, offered an escape from the ordinary scene, on an island that already represented the ultimate getaway. Thomas Elliott stands on the right.

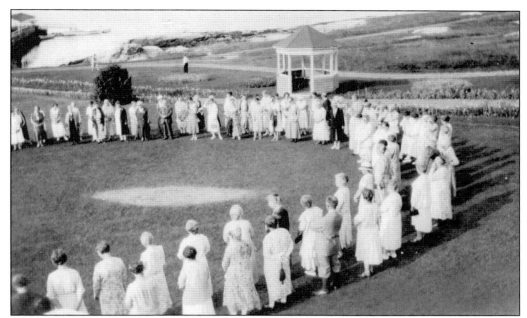

Outdoor activities, of course, ruled the summer days on Star Island. This group may be performing a grand procession, but in the very least have headed outdoors in their best clothing for some sort of ceremony.

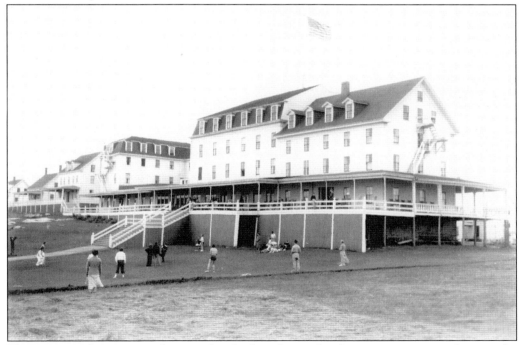

The group in the previous photograph, whether they realized it or not, were standing on the ancient ball field of Star Island. While the open green grass area is certainly conducive to playing baseball, outfielders soon find that their domain includes the shagging of fly balls in the small cemetery near the summerhouse.

Samuel Atkins Eliot II, the president of the American Unitarian Association from 1900 to 1927 and the son of the president of Harvard University, visited the Isles of Shoals in 1935, obviously with some pomp and circumstance. The Harvard Divinity School still holds his notes for what he called his "Talks on the Rocks," at the 1914 rededication of the John Smith Monument.

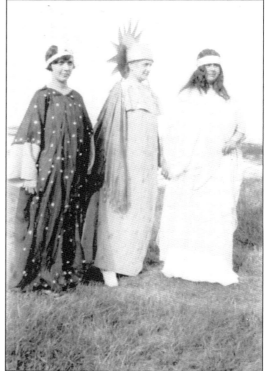

Costumed pageants were always a fine way to celebrate life on Star Island. One of the most dramatic came in July 1931, with a ceremony reenacting the dedication of Star Island 15 years earlier.

With signs of agrarian life in the background, this couple looks over the natural beauty of the Isles of Shoals. The sweeping scenery of the postcards and photographs of the first half of the 20th century often evoke romantic notions from earlier centuries. Had there been cameras at the time, this scene could have appeared in the 1800s or even the 1700s.

In a scene more or less lost today, daisies sprout from the grasses beyond the turnstile, in view of the rear of the Gosport chapel.

Since the first conference in July 1897, it has taken a small army to take care of even the basic necessities that the attendees need. For several decades, that army has been formed by seasonal help, migratory young people from the mainland known as "Pelicans," or "Pels" for short. They come for the summer, make the beds, haul the luggage, run the fire drills, wait the tables, and then go home once the fall weather arrives. But they do have their fun. Each year the Pelicans put on talent shows, and they have their own little secrets that are passed from Pelican to Pelican through the generations, like the best places to swim together after dark. This young woman, Iris Fabius of Ridgewood, New Jersey, has just returned from a "mission of mercy," most likely the delivery of water to somebody desperate for it on a hot day. Such acts have become the norm for Fabius. Now Iris Fabius Kiesling, in March 2007 she received a lifetime achievement award from the community of Bloomington, Indiana, for her dedication to public service.

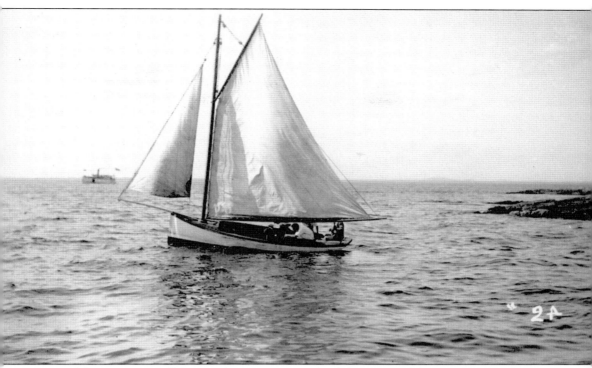

Part of the enjoyment of life as a Pelican came from the ability to spend the summer in exploration of the islands. Early on, it was this boat, the *Pelican*, that allowed them to venture out around the islands and see them from all sides. The boat got its name from its slight resemblance to the elongated bill of a real pelican, and the youngsters took their name from the boat.

While Pelicans thoroughly enjoyed their seasonal visits to the Isles of Shoals, soon, life gets in the way. The economic realities of life force them into career choices that preclude them from returning in ensuing summers. Oftentimes they return to the island as conference attendees or to attend Pelican reunions. Here in about 1963, Rozie Holt, former hotel desk registrar, Marjorie Neagle, former Vaughn Cottage curator, and Margaret Odell, from the hotel store, relive some past adventures on Star Island.

Familiar faces to many in the summers, Dave and Edith Pierson served as Star Island's winter caretakers from 1975 to 1994. Dave was also the island's engineer, an important man to have around through all seasons, and Edith was simply known as the "queen of all things" to those folks who needed help around the island. In order to stave off vandalism on the susceptible Smuttynose Island, she formed the "Smuttynose Rangers." The Piersons retired to Eliot, Maine.

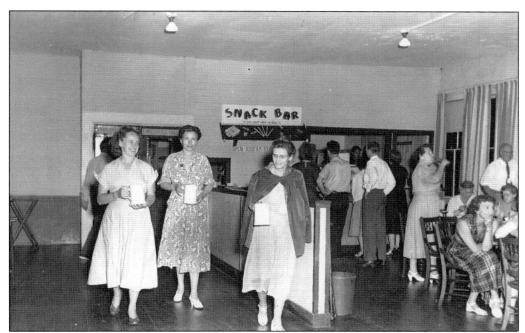

The Oceanic Hotel, while a fabulous pace to stay, could not provide one thing: running water in each guest room. If one wanted water for the evening, they simply had to ask, and they would be provided with a porcelain pitcher to be carried to the room, as demonstrated by these young women.

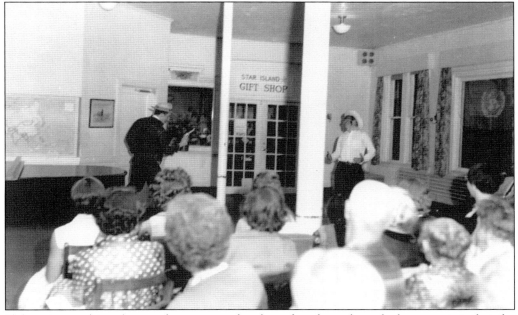

If there is one thing that conference attendees have found out through the years, it is that the Pelicans are a talented group of people. Not only can they cook, clean, and generally make life easy for folks seeking relaxation, they can sing, dance, and act as well, as illustrated in this image of a Pelican show.

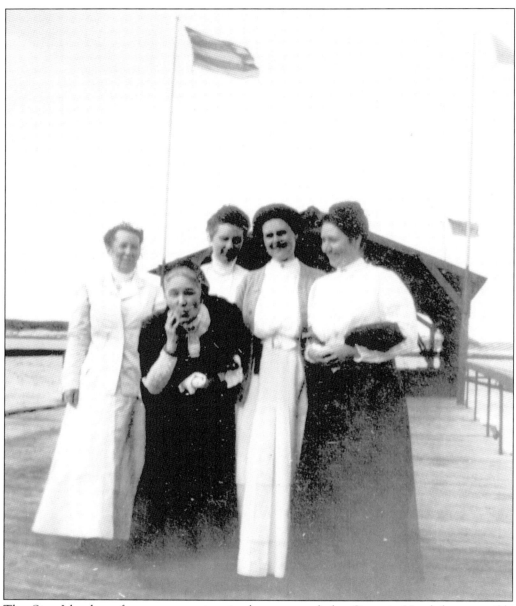

The Star Island conference era, quite simply put, saved the Oceanic Hotel from possible dilapidation and ultimate destruction. More than that, it has given the Isles of Shoals a mystique that pervades all of New England, as there are now only two types of people in the region: those who want to visit the Isles of Shoals, and those who have visited and want to go back. Today the conferences are going strong, reaching more deeply into the season, with visitors coming for specialized weeks on religion, natural history, and family escapes well into September. The most important facet of the Star Island conferences though is the ability to relax even the most straight-laced person into a position where she feels comfortable enough to let her inner child out just in time to be caught by the camera, like these women mugging at an early conference. What began by a quirk of fate—the ill health of the wife of a Unitarian minister—has become a rite of passage for generations on the Isles of Shoals.

Six
SPECIAL PLACES

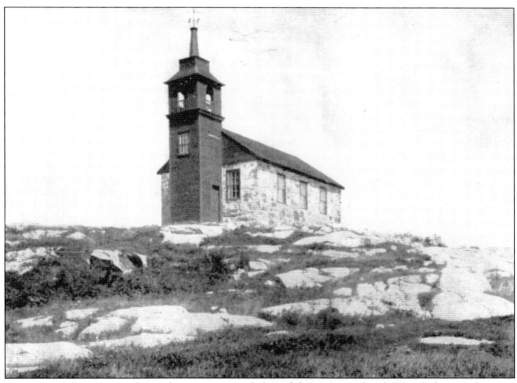

European fisherman in the 17th century cured their fish on Star Island. This led to settlement. The town of Gosport was established on Star Island in 1715 by the province of New Hampshire. The town at the end of the 18th century was in decline. By the end of the Civil War, the town was in debt. In 1872, John R. Poor acquired all but two parcels of land on Star Island and built the Oceanic Hotel. In 1916, the Star Island Corporation established a conference center here on behalf of the Unitarians and Congregationalists. Since 1800, this chapel has stood above all that took place on the island.

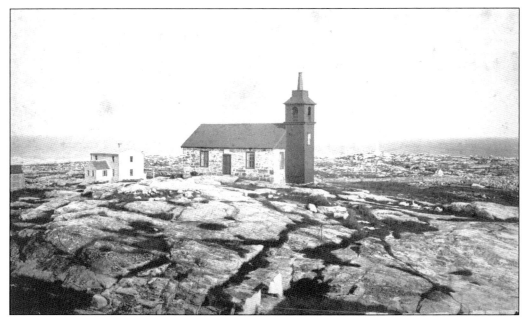

A chapel was built of wood on this highest point on the island as early as 1685. This was replaced in 1720, and this building lasted until 1790 when it was burned and replaced in 1800 by the one depicted here. This 1884 view shows the parsonage, which was built in 1802, to the left of the chapel. This parsonage burned in 1905. To the right of the chapel in the background is the Capt. John Smith Monument.

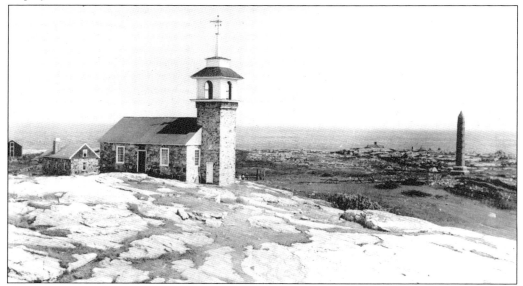

The chapel gained a bell and a weathervane in 1859. The wooden tower was blown down in 1892. Oscar Laighton rebuilt the tower in stone in the same year. To the left of the chapel is the stone parsonage built in 1927 on the foundation of the previous one. To the right of the chapel, the turnstile can be seen, which is the place in the fence that allows one to pass between the village and the grazing areas. Further in the background is the Capt. John Smith Monument without its column. Further to the right is the Rev. John Tucke Monument, erected in 1914.

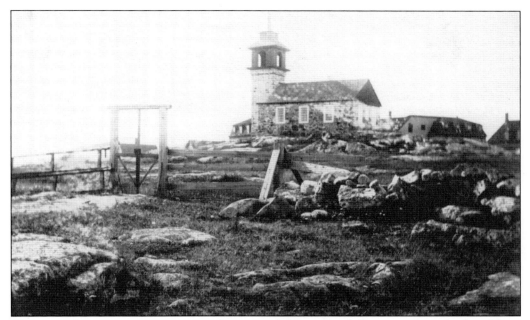

The turnstile was a convenience in the time of the town of Gosport, when the hotel kept livestock. Since the livestock have gone, the turnstile has been maintained as a reminder of the past. The turnstile has a symbolic purpose. Just as it was a passageway from the village to the pasture, a Star Island conference has been a turning point from the temporal to the spiritual for many attendees.

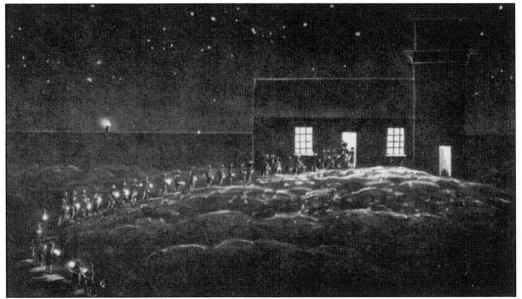

In the evenings during a Star Island conference there is a chapel service. The participants go in procession from the hotel porch carrying a candle lantern. This ritual dates from about 1903. In this depiction, it is a starry night, and the lighthouse is visible in the background. In the village days, the chapel was a landmark to sailors, and at night, the chapel lights often helped guide fishermen home.

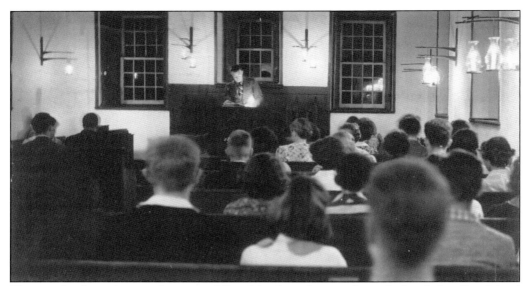

Thousands of people over the time of Star Island conferences have declared that Star Island is their spirits' home. The chapel service is the center of this spiritual life on the island. In this evening service, one can see the candle lanterns hanging on wall brackets and the shadows they cast. The brackets are reproductions of one found in the rubble of the disused chapel about 1898 by William Roger Greeley, who served as president of the Star Island Corporation (1948–1954).

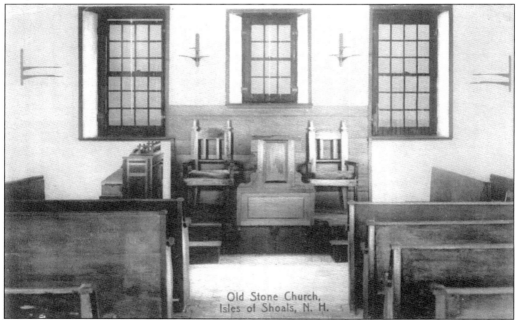

This interior view of the chapel reveals the straightforward arrangement of pews and pulpit and the lantern brackets with their cross ends. When the town of Gosport was disestablished in 1876, the chapel fell into disrepair. In 1897, with the beginning of the conference period, the chapel was restored. The old pulpit and benches, complete with their graffiti, were restored. A brick floor replaced the rotten wood by the first decade of the 20th century.

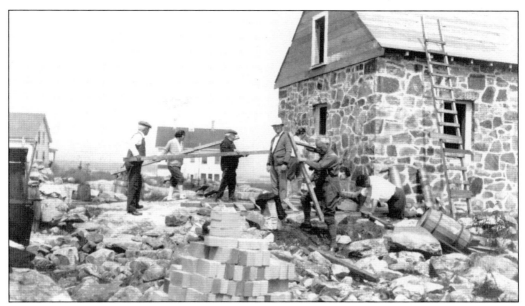

This stone parsonage was built on the foundation of previous parsonage buildings, which were built of wood as early as 1732. Rev. John Tucke was the minister and doctor at Gosport (1732–1773) during the time when fishing brought prosperity to the Isles of Shoals. It is in his honor that this parsonage is called the Tucke Parsonage. This is also the first of five stone buildings that make up the "New Gosport" built in the 20th century.

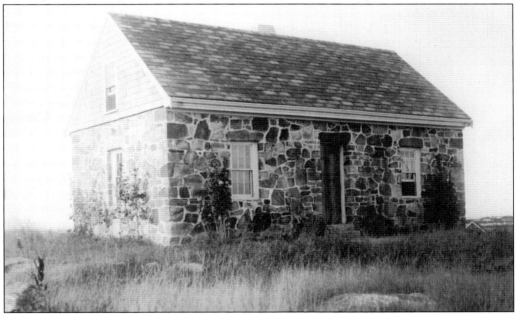

The parsonage was designed by William Roger Greeley, who chaired the committee in 1927 with the responsibility to increase accommodations on Star Island. He also designed the Asa Merrick Parker Building (1948), Newton Centre Parish House (1953), and the hotel units (1953–1955). Greeley worked as an architect and city planner in Boston. He gave great knowledge and service to the success of Star Island.

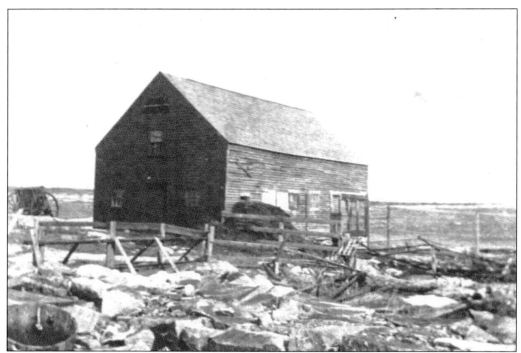

The villagers of Gosport had their personal livestock. During the hotel and conference periods, there were a variety of livestock living on the island. Cows, sheep, hogs, and turkeys were all kept. Small barns such as this one were typical.

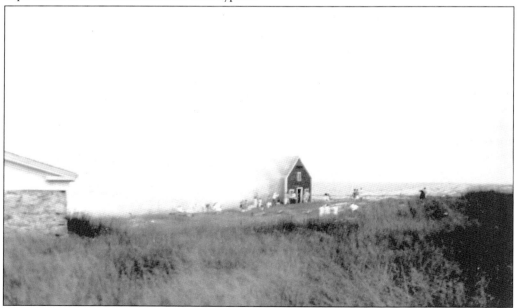

Fire is always in the back of one's mind on Star Island. This fire, a grass fire, is one of the most dangerous. Although there were lots of people around, there was little they were able to do to prevent the spread of the fire or to save the barn. Note in the foreground grass and weeds similar to those that are burning.

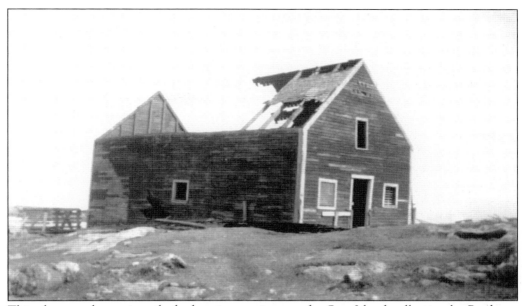

This photograph was inscribed when it was given to the Star Island collection by Prudence Randall, "The old barn that burned around 1934 stood near the shore on the rise of ground just east of the present caretaker's house." Randall's father bought Lunging Island in 1926, and she has spent many summers at the Isles of Shoals, even serving as one of the Pelicans on Star Island.

Shown here is another barn on Star Island. One small barn became the art barn, located by a small pond from which ice was once harvested. The ice was stored inside this barn. The first diesel engine on the island to make electricity was installed in this building. The water for various needs of the island was also supplied from the pond.

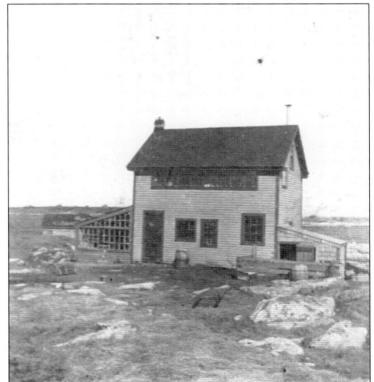

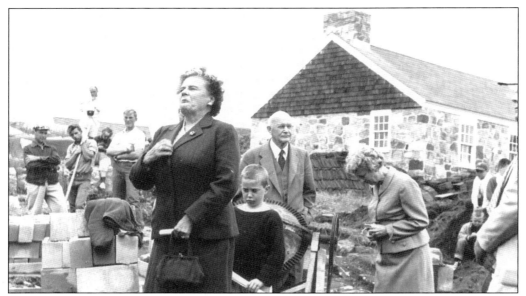

Rosamond Thaxter, granddaughter of Celia, spoke at the groundbreaking ceremony for Vaughn Cottage. When Oscar Laighton died on June 26, 1939, there was a strong desire to have a memorial to Uncle Oscar and the Laightons. After World War II, Hallie Vaughn was looking to create a memorial to her late husband, Charles. The two efforts were combined in Vaughn Cottage. Rosamond Thaxter donated many objects related to Celia and the Laightons to be displayed in the museum room.

As soon as the prayers and speakers for the ground ceremony for Vaughn Cottage were finished, work began. This is Dick Soule, the main contractor for Star Island from 1946 to 1960. He maintained all the buildings on the island and built Vaughn Cottage as well as others in the post-war period of expansion of the conference center.

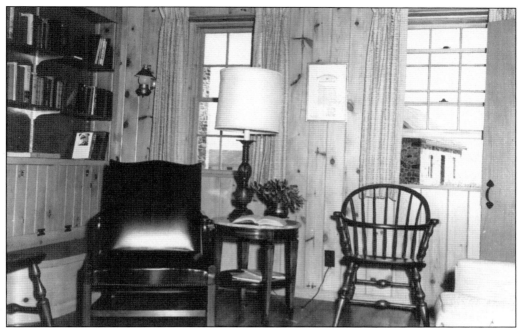

Vaughn Cottage was designed by Charles Cole. The first floor is divided into two rooms. To the left of the entrance is the Celia Thaxter Room, used as a museum. On the right is the Charles F. Vaughn room, depicted in this photograph. This room serves as a library and a comfortable room to read and meet. The interior is finished pine panels and hardwood floors and is furnished with furniture acquired for this building.

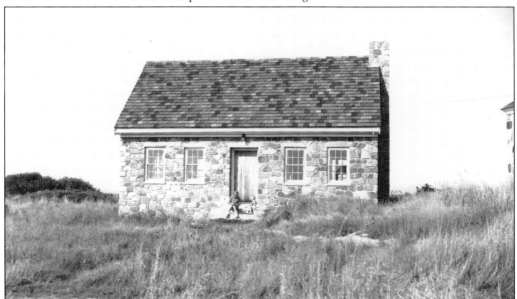

Since 1960, Vaughn Cottage has served as the museum of the Isles of Shoals. Included in the collection are the photographs that are in this book and many more. Because of the collection and study that has been centered in the Vaughn Cottage, books, exhibitions, articles, and preservation of the history and art of the Isles of Shoals have been enriched.

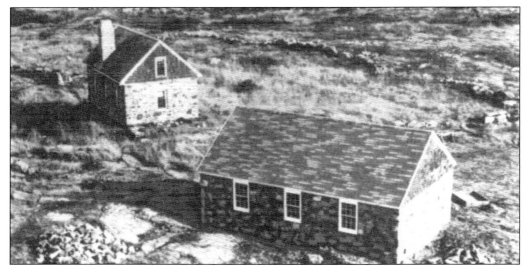

The 1920s were a busy time for the Star Island Conferences. With attendance and enthusiasm high, it was recognized that planning was needed to ensure the future success of the conferences. The Star Island Corporation established a committee for increased accommodations. The idea of a New Gosport of stone cottages was a result of this planning. All expansion stood still until after the Great Depression and World War II. When the island opened after the war much work was needed to restore the facility after being shut down for four years. In 1948, the stone cottage in the foreground of this postcard was built, the second building in the New Gosport. The building was named in honor of Rev. Asa Merrick Parker, who was president of the Isles of Shoals Congregational Corporation (1938–1948). In 1953, another much larger stone building was added to the collection. This building is the Newton Center Parish House. The Newton Center Unitarian Church of Massachusetts was united with two other churches, sold their church building, and gave money from the proceeds to build the Newton Center Parish House. Vaughn Cottage completed this collection until the Barbara Marshman Cottage was built in 1998.

With the building of the Oceanic Hotel in 1873 came a plant to provide gas for the gaslights. The generation of electricity was accomplished with the installation of a diesel engine in the old icehouse. In 1960, this new utility building was built, housing two diesel engines and two seawater converters. In the foreground, the "truck trestle" can be seen, which was built over a dip in the rock to enable the island truck to make a circuit around the hotel. In the background is the staff lodging building known as the "Shack."

This is the rear of cottage D. This building is used for offices and guest rooms. John Bragg Downs built this house in 1850s. He and the Reverend George Beebe were the only people who did not sell their land to John Poor. They remained on the island while the rest of the villagers moved off. Some regretted moving and offered to buy Downs's house.

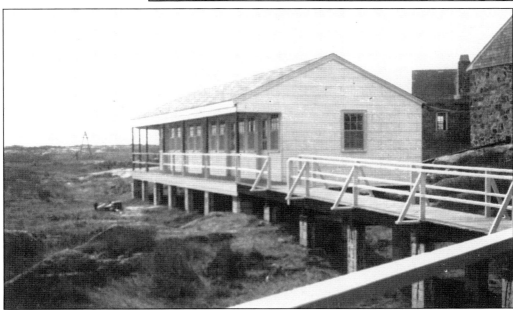

In the early 1950s, the third and fourth floors of the Oceanic Hotel were not open to guests. In order not to lose occupancy, it was decided to build two motel units of five rooms each. The first were built in 1953 and named Isaac Sprague and Founders. In 1955, two more motel units were built, named Young People's Religious Union (YPRU) and Frances M. Baker. The building in this view is the YPRU unit.

This building known as the Shack dates to the building of Oceanic Hotel and was used as the site of the plant that produced illuminating gas. The gas was produced by distillation of coal. The hotel was piped for gas, and the rooms had gaslights. Fred McGill, an island historian who attended conferences in the 1920s, remembered the match holder in the rooms for lighting the gaslight. When electricity was introduced to the island the Shack was made into staff quarters for the junior staff Pelicans.

Seven

CAVES AND WAVES

Millions of years of erosion and glacial activity are evident on all nine islands. Geologists believe the Isles of Shoals, once part of the mainland, were actually lowland hills. Chasms, interesting rock formations, and glacial boulders are scattered about. A four-foot deep glacial pothole, nicknamed Neptune's Punch Bowl, is located on the north side of Star Island. Trap dikes and depressions, caves and cliffs provide endless opportunity for exploration. Although treeless, and despite a lack of abundant soil, flora and fauna abound. The islands are home to greater black-backed and herring gulls, egrets, and cormorants, as well as hosting an array of migratory birds. Green snakes and groundhogs are in residence. Marine mammal sightings include harbor seals, whales, and the occasional dolphin. There is an endless list of flora including wild rose and iris, sumac and deadly nightshade, and poison ivy so lush it is the size of small trees. Garnets and crystals, quartz and black tourmaline are caught in the rocks. A nature-lover's paradise, these islands call out to island visitors to spend countless hours exploring their natural history.

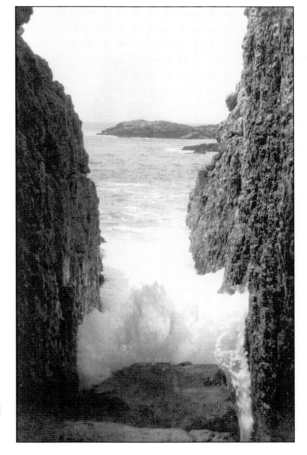

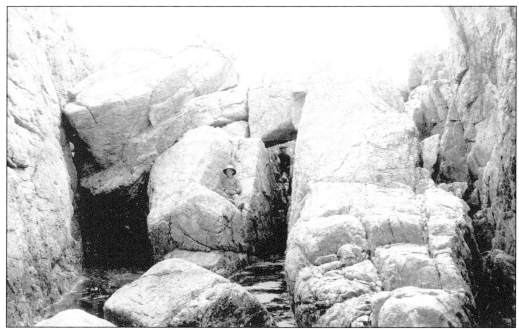

This trap dike runs along eastern Star Island forming a crevice four feet wide and a cave made by the collapse of huge boulders. Named Betty Moody's Cave, it is a favorite destination for adventuring children. During a Native American attack in 1724, Moody and her small children hid there. Legend says that, in an effort to stifle her baby's cries and avoid discovery, she inadvertently smothered the child.

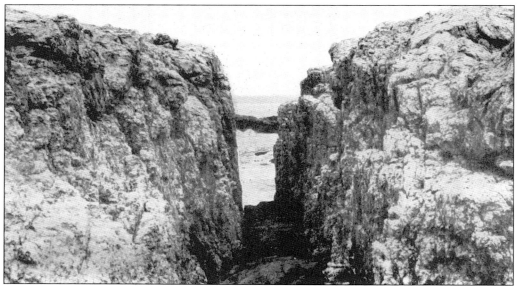

The caption on this postcard reads "Siren's Grotto, Star Island." This is correct in that it is Star Island, but it is not the Siren's Grotto. This is another view of the trap dike near Betty Moody's Cave. Siren's Grotto, or Siren's Cove, is actually located at the north end of Appledore Island. Misidentification of the various geological formations is not uncommon as several of the islands have similar features.

Another popular destination for visitors is this formation, also found on the east side of Star Island. East Rock, as it is most commonly referred to today, has several names including the Old Man of the Sea, Sunrise Point, and Caswell's Peak. On the back of this stereoview is written "Great Uncle who was insane jumped from this peak into the ocean." At night, the surf at the bottom of the 40-foot drop is full of phosphorescence, tiny marine organisms glowing in the dark.

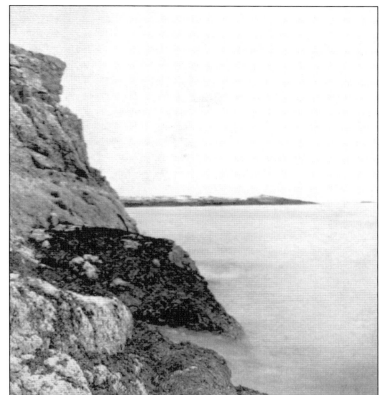

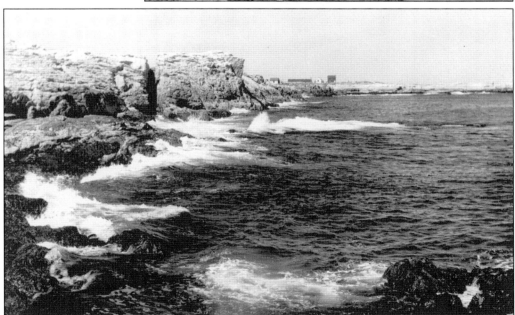

Shown here is another view of East Rock, showing the trap dike and the pounding surf. The eastern end of Cedar Island and several buildings are visible in the background. Note the Long House, which was moved from Smuttynose Island around 1890.

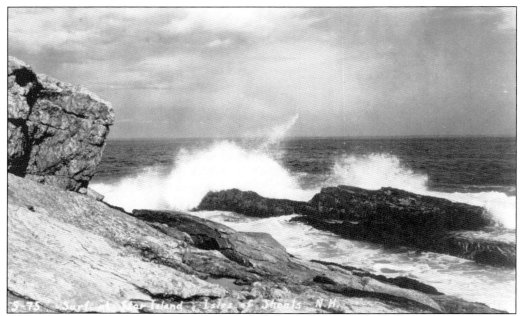

Located just south of East Rock on Star Island, lying along the dike and at the foot of the cliffs below the Capt. John Smith Monument, are the Marine Gardens. Here are two different views of the location, the top image at high tide and the bottom image at low tide.

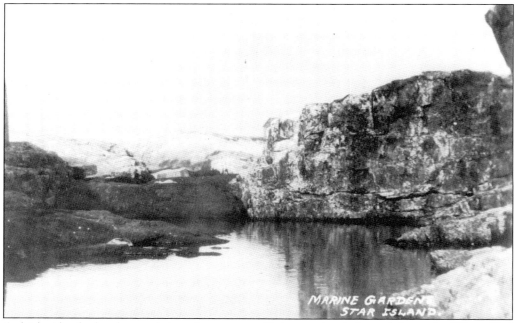

At high tide, the breakers rush into the many small chasms chiseled out of the rocks. When filled with seawater at low tide, these pools can safely be explored for their abundant marine life.

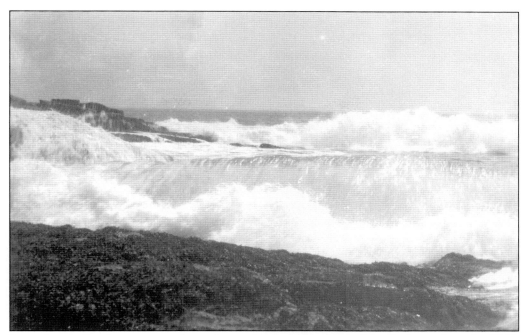

Several tragedies have occurred on the southern point of Star Island, shown here. In 1848, Nancy Underhill, an island schoolteacher at the time, was sitting on a ledge at this end of the island when a rogue wave rose up 40 feet and swept her from the rocks. Days later, her body washed up in York, Maine.

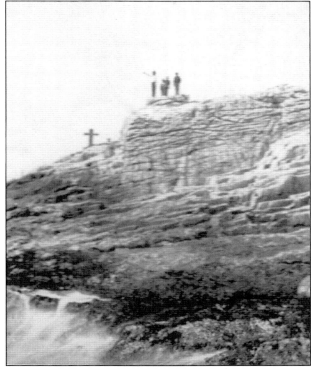

Here note the cross marking the spot high up where Underhill was lost and the tourists visiting the site. In the 1920s, a similar tragedy occurred when a young male visitor to the island, fishing from the same area, was swept away. His body was found nearby. Other rogue waves have surged there as well, giving rise to the theory that the geology of the ocean floor here may be particularly susceptible to this phenomenon. Nearby is a rock formation known as Lover's Cave.

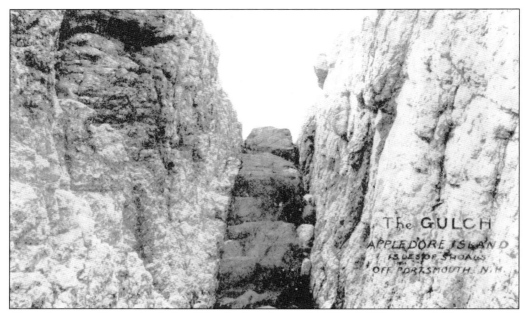

Above is a trap dike on Appledore Island referred to as the "Gulch." The smooth black material in the center of the photograph is ancient lava. Originally named Hog Island for its resemblance to a hog's back to sailors approaching from the sea, Appledore was the first center of population on the islands. Being the largest island at 95 acres, settlers were drawn to its size. Also attractive was its fresh water pond and supply of soil for gardens and grazing animals. The one attribute it lacked was a good harbor.

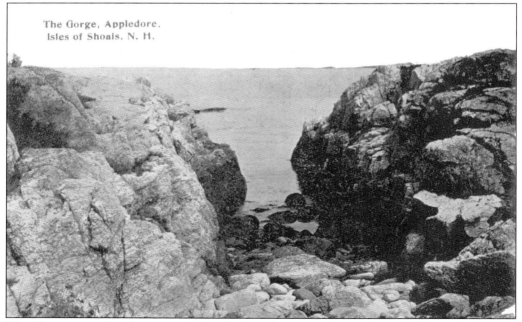

The Gorge is another formation on Appledore. Famous artists, such as Childe Hassam, found these geological features fascinating to paint.

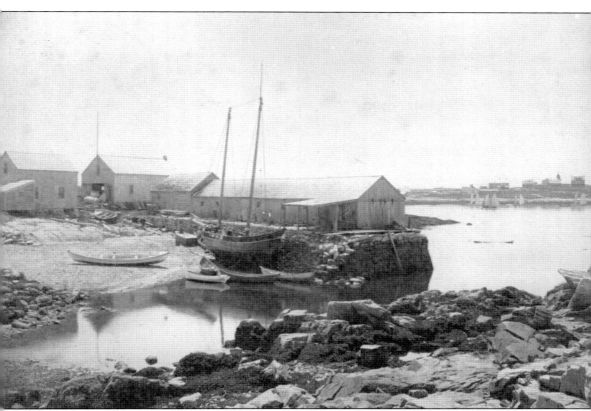

Approximately 27 acres, Smuttynose Island was named by sailors who noted a black smudge on the eastern tip of the isle. In the 1600s, there was a slow migration from Appledore Island to Smuttynose Island due to its superior harbor. Flanked by Malaga Island (right) on one side and Cedar and Star Islands on the other, it offered a roomy and safe harbor that Appledore Island could not provide. Other qualities included a freshwater well and a good deal of soil. Around 1800, Samuel Haley found several bars of silver under some rocks on the island. With it, he constructed a seawall connecting tiny Malaga Island to Smuttynose Island, creating Haley's Cove. In 1821, the United States government built a breakwater connecting Smuttynose and Cedar Islands. On the southeast tip of the island is a cavern, Maren's Rock, which aided in saving the life of Maren Hontvet as she hid from the perpetrator of the horrific Smuttynose murders of 1873, the axe murders of two young Isles of Shoals women, Anethe and Karen Christensen.

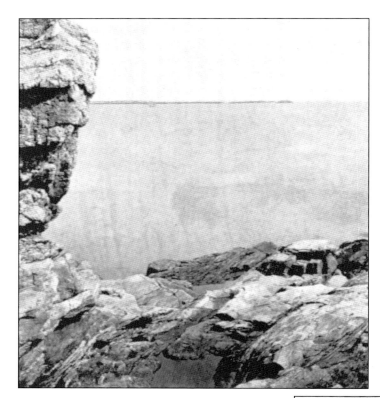

In the distance is Duck Island, taken from Appledore Island. Note the small craft in the water. The northernmost of the islands, it lies about one mile northeast of Appledore Island. Low-lying, it is actually a series of tiny islands or rocks. During World War II, Duck Island was used for target practice. Purportedly there may still be unexploded bombs in the area. Today it is a wildlife refuge for harbor seals and cormorants.

The inscription on this image identifies "Walter B. Hayden, Duck Island, 1927." There was, undoubtedly, good duck hunting on the islands. One early account relates the taking of 30 or more ducks at one time. They were of great value to the native Shoalers, who used them to stuff their pillows and featherbeds, as well as for food.

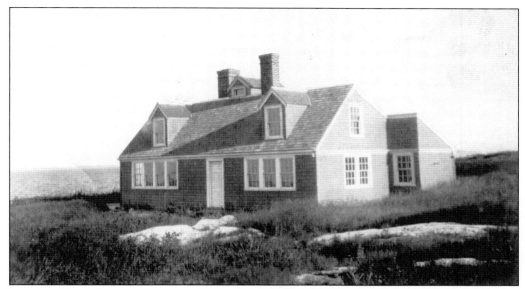

Lunging Island, located just west of Star Island, is actually two tiny islands connected by a bar or tombolo. Originally called Londoner's Island, it has a rare beach and snug little harbor. An eight-foot-wide trap dike cuts through the northwest corner of the island. Pink garnets and black tourmaline are imbedded in its granite. As on the other islands, there are tales of pirate treasure, buried in an underground cave. This image of the 19th century Honeymoon Cottage was taken in 1925.

Once owned by Oscar Laighton, Honeymoon Cottage was sold to and remodeled by architect Frank Ferguson in the 1920s. Shown here are three generations of the Ferguson family, Frank; his son, Donald; and grandson, Malcolm, on Lunging Island about 1924. Today the island is owned by descendants of Rev. Frank Crandall of Salem, Massachusetts.

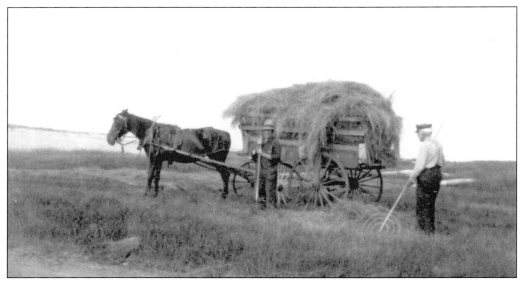

With little grazing available, the islands supported a modest amount of livestock, which included sheep, turkeys, chickens, pigs, horses, and an occasional cow that provided milk for the small children of the village. In the 1800s, Cedar Island was sometimes utilized for grazing animals as well as growing vegetable gardens. This photograph, probably taken around 1930, is inscribed "K. H. Andrews haying on Star."

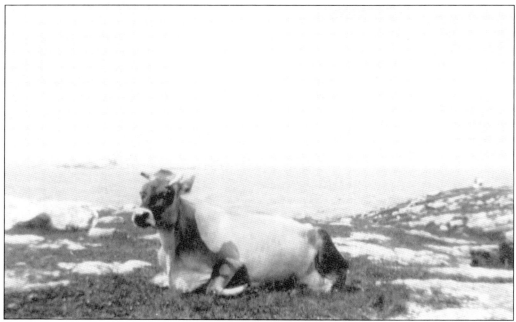

Here is an island cow caught resting in 1916. The islands in the distance may be White and Seavey Islands. White Island, early home of the Laightons, is connected to Seavey Island with a tombolo that is underwater at high tide. The southern part of White Island supports the 85-foot-tall lighthouse, and Seavey Island is a nesting place for terns. Both of the islands are named for old Shoalers.

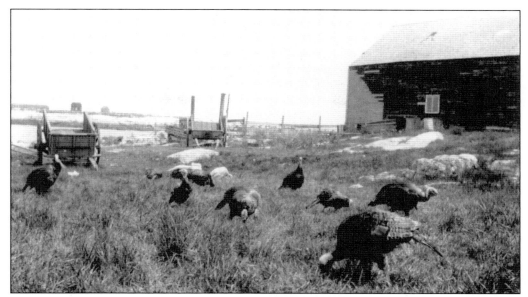

Turkeys were imported to Star Island during the early conference era to control a pestilence of grasshoppers, as well as to feed conferees. In this photograph, turkeys graze near an early barn that burned in 1934. Cedar Island and several of its buildings are visible in the background.

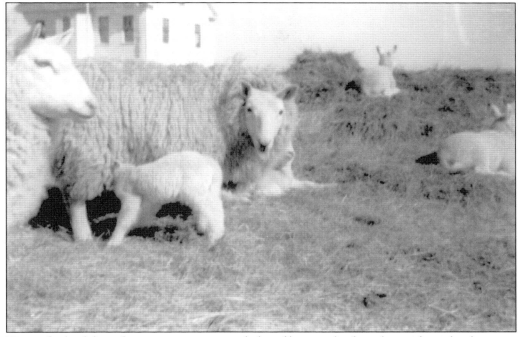

Here a flock of sheep lies in repose amongst bales of hay on the front lawn of an island cottage in 1939.

For centuries, the unique landscape of the Isles of Shoals has drawn many to these stark and barren, yet fiercely beautiful islands. Fishermen have come to fish, conferees to reflect, and artists to paint.

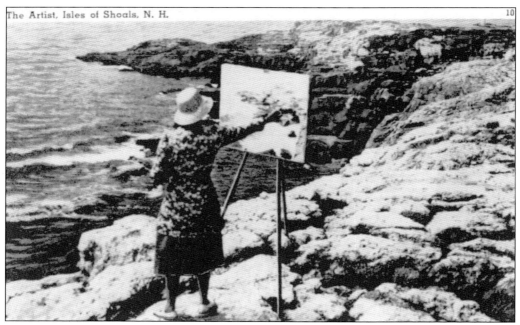

The following is inscribed on the postcard titled "The Artist, Isles of Shoals, N.H.," "Arrah Lee Gaul of Philadelphia, drenching her canvas with the sunshine of Star Island. Her vivid canvasses of the Shoals, done in 1947, have been exhibited in many museums. White Island Light in the distance."

Eight

UNCLE OSCAR LAIGHTON

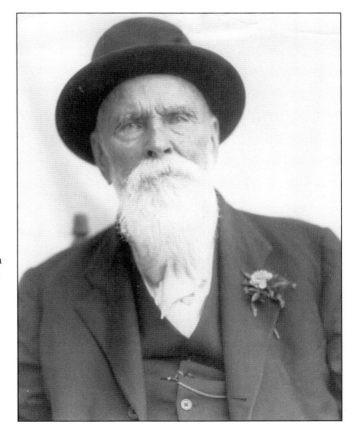

Oscar Laighton's eyes were the eyes of the Isles of Shoals. The son of Thomas and the brother of Cedric and Celia, Oscar arrived on the islands at three months old in 1839 and stayed for the next 99 years. Together the siblings grew up like "seabirds on the rocks, 'cared for by the sweetest mother in the world,'" according to Aubertine Woodward Moore in *New England Magazine* in 1898. By the end of that century, though, Oscar would be the only member of his immediate family still alive. He stayed on for three more decades, in his own words "an old derelict riding at anchor in Gosport Harbor." If Celia Thaxter was the heart of the Isles of Shoals, Oscar held its soul.

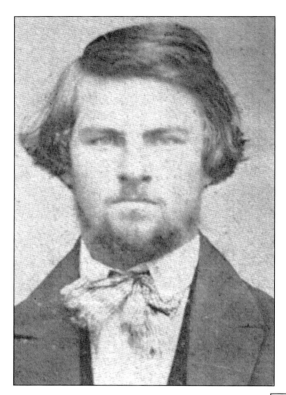

Contrary to what most of the photographs of Oscar Laighton indicate, he was not born an old man. In his earlier days, the dashing young Oscar was known as a ladies' man, wooing the young daughters of visitors to his father's Appledore House each and every summer. His memoirs, *Ninety Years at the Isles of Shoals*, chronicle many of his ultimately failed love affairs.

Coming of age when he did, turning 21 in 1860, Oscar's ultimate choice in facial hair reflected the style of the great men of the day. His beard grew out of the days of Abraham Lincoln, Robert E. Lee, and Ulysses S. Grant. As it whitened in old age, it became almost as much of an Isles of Shoals landmark as the Gopsort chapel.

By the time he was 48 years old, as shown in this picture, Oscar had not only intermittently left the Isles of Shoals (he visited Portsmouth by sailboat and saw his first horse at 16), he had traveled extensively in Europe with his sister Celia. He had been written about by Nathaniel Hawthorne in the author's *American Note Books*, had his own poetry published in *Atlantic Monthly*, and rubbed elbows with the most famous writers and artists of the day.

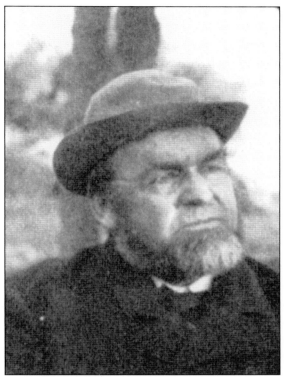

Here in a rare photograph of Oscar on the mainland, he poses at 48 years old in 1887 with Liz Philbrick and her children in Rye. Philbrick ran the Farragut and Atlantic House hotels in that community. By that time, Oscar and his brother Cedric had taken full charge of the Appledore House and were veterans of the seasonal business.

The "Uncle" Oscar Laighton that is remembered today, by the very few still alive who were fortunate enough to meet him, looked the same in almost every photograph: black suit with vest and long coat, white beard, bowler hat, and a wide, almost mischievous smile. He may have been the most photographed septua-, octo- and nonagenarian in New England in the early 20th century.

Laighton loved the sea, and it showed in his memoirs. He often mentioned his personal mantra of always "keeping an eye to windward," so as not to get blindsided by life's storms. He sketched the boats that sailed nearby, delighting in beauty only discernable to a true mariner's eye, learned to navigate the islands as a boy, and manned boats into his latest years.

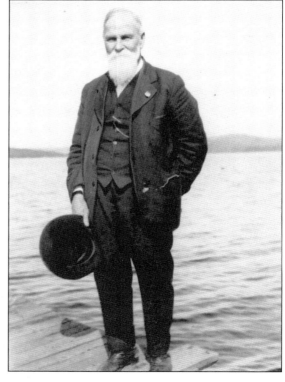

Laighton received his first scope, a small hand held spyglass, from a visitor to White Island during his youth, a gift from judge Charles Levi Woodbury. His more famous scope, for which he built an observatory off the piazza of the Appledore House, came also as a gift. Upon hearing of Laighton's love of astronomy (which was enhanced in his mind by the effects stargazing had on beautiful young women), friends raised $500 to purchase one for him.

Any person alive at 90 years old has stories the world wants to hear. A survivor of 90 years on sparsely populated islands, however, has stories that no one else can tell. Laighton wrote poetry and songs for his privately published book *Songs and Sonnets* and also tackled his memoirs, *Ninety Years at the Isles of Shoals*. Upon its publication, he told friend Lyman Rutledge, "Just wait ten more years and I'll give you a book on One Hundred Years at the Isles of Shoals."

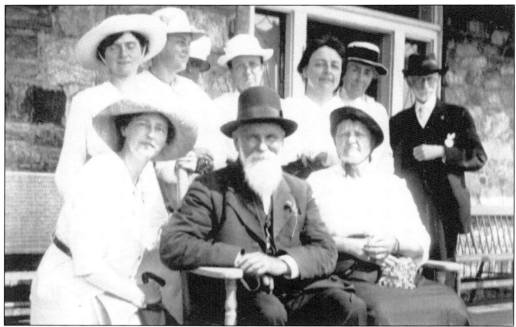

As Oscar Laighton aged, he became the mascot of the islands, the symbol of all that the islands stood for. Once tourism took center stage at the Isles of Shoals, he became heavily sought for pictures, posing with groups of all sizes. In this gathering, Jessie Donahue stands fourth from the left in the second row, Mrs. William Lawrence kneels to the left of Laighton, and Polly Lawrence sits at his side.

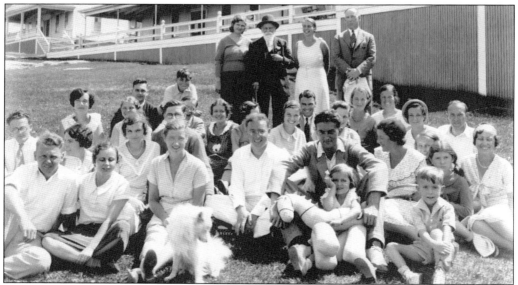

The consistency of his dress makes it hard to determine the age of photographs solely of Laighton. But, when photographed with groups of people, it becomes easy to identify time periods in which the photographs may have been taken. For instance, a simple study of American fashion through the ages states that no person, especially a woman, would be seen in shorts in public until the 1920s. This picture was probably taken between then and the 1930s.

It was not only groups that wanted to bring proof of their acquaintances with the famous Laighton home with them. Individuals like this dapper dude of the c. 1912 era sought Laighton out as well.

Not everybody was that enamored of having their picture taken with the old man, as demonstrated here by the pouting face of Betty Wetherell.

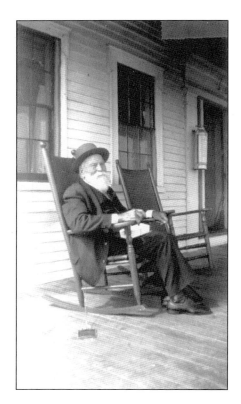

Yet even with the madness of the tourism and conference eras on the islands, Oscar Laighton still found time to enjoy the solitude necessary for the maintenance of his soul. His favorite spot on the far end of the Oceanic Hotel piazza, had all he needed: a rocking chair and a fly swatter.

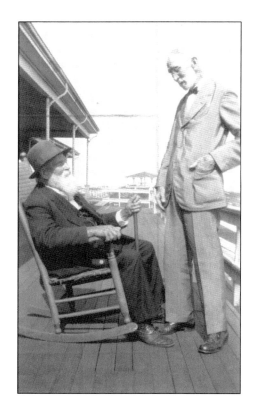

Occasional old friends would stop by, like Thomas Elliott, a founder of the conference era on Star Island.

At other times, when the time was right, when baseballs had been smacked around enough, the burial grounds had been explored enough, and the island's gulls had been harassed enough, youngsters might find time to pull up their own rocker and spend a few minutes regaled by the old man's tales.

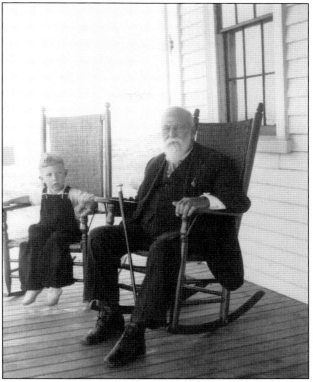

Through the years, Laighton watched them all come and go, seeing young turn to old before his very eyes. He often thought of the early days on the Shoals, "To think that every one of the dear people I knew at that time are gone forever! I cannot recall one now living. It seems strange that I am still on deck. I hope the Lord has not forgotten me." In many ways, Laighton could be alone in a crowd.

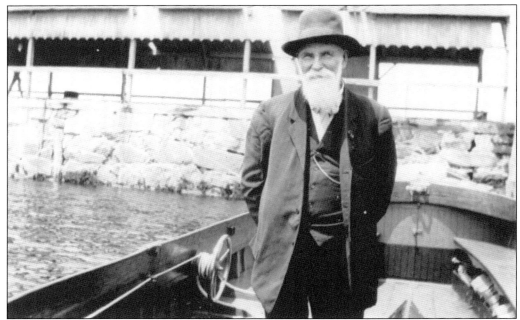

From the time of Oscar Laighton's youth, boats had been a passion. *Twilight*, his personal launch, introduced many island-hoppers to the majesty of the Isles of Shoals. Laighton also used personal craft like *Twilight* to get him from Londoner's Island, where he built and occupied Honeymoon Cottage (an odd name for a home lived in by a man who never married) and to Appledore and Star Islands.

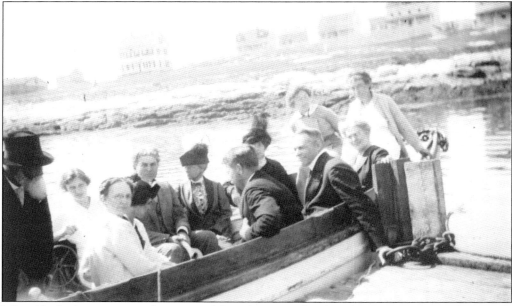

Life with the boat was not always easy. More than once Laighton's name appears in the records of the United States Life-Saving Service and the Coast Guard as being someone in need of aid. Mostly those occurrences had to do with the early, balky and recalcitrant outboard motors of the day, and nothing with Laighton's seamanship.

Without any roads on the islands, Laighton saw no need to get his license until, that is, he turned 90. This popular postcard view shows Laighton in a very unexpected position. In his memoirs, he blamed the coming of the automobile for the fall of the tourism era on the islands and the reason his family had to sell off their assets that led to the opening of the conference era. Whatever disagreement Laighton had with automobiles had been buried by the time this photograph was taken in the 1930s.

Birthdays got lonelier and lonelier for Laighton as the years went by. Cakes got bigger, more candles were added, as seen here on his 95th or 96th birthday, and while crowds were always around, it was the lack of familiar faces from his youth that pulled at his heartstrings the most. By the time of this photograph in 1934 or 1935, all members of Laighton's immediate family had been dead for more than three decades.

111

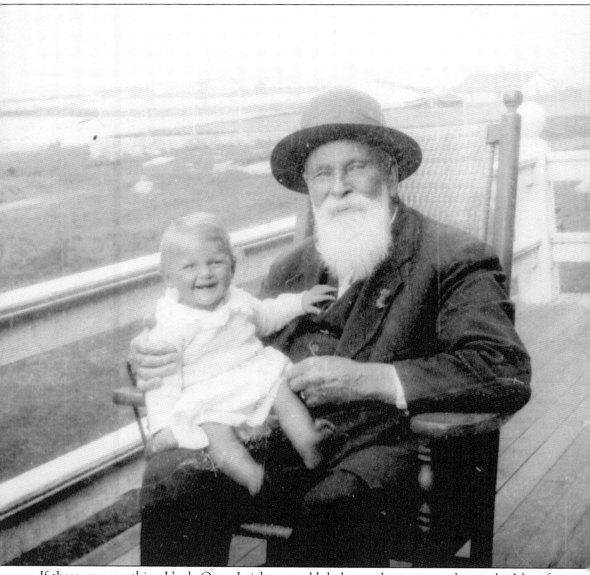

If there was one thing Uncle Oscar Laighton could do better than anyone else on the Isles of Shoals, it was to make new friends. He arrived on White Island when Andrew Jackson was president of the United States and when he passed away in 1939, Franklin Delano Roosevelt held that seat. He had witnessed the Mexican War, the Civil War, the Spanish-American War, World War I and passed away on the cusp of World War II, and he had seen the Isles of Shoals go from fishing station to summer tourism capital to religious retreat. At his memorial service held in the stone chapel on Star Island, the attending reverend used Laighton's own maritime analogies when referring to his life: "Uncle Oscar has put out to sea with all sails set . . . We have heard no one say that he has passed away, or is gone, for we all feel his presence, and go with him in spirit as he beckons us to voyage with him over the limitless seas. Today," the reverend continued, "he is dipping the prow of his fishing boat into the radiant path of the rising sun with the glory of the dawn gleaming in his snow white hair, guiding us homeward to the Islands of the Blest."

Nine
BOATS AND MORE BOATS

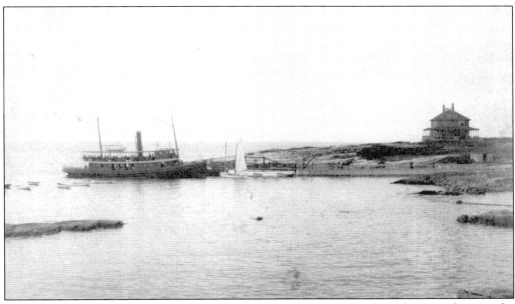

Boat transportation is the key to sustaining an economy on any island. By the time photography became common, sailing ships were on the decline and vessels with engines were doing most of the commercial work. The first steamboat to serve the Isles of Shoals was the *Pioneer* in 1866. Boats took people and important goods back and forth to the Isles of Shoals, for the most part without incident, some working for a short time and some with many years of service. Besides transportation, they provided opportunities for individual experiences and the kindling of lifelong friendships. In this photograph, the boat at the Appledore Island float is the steamer, which went into service in 1873. She came with the name *Major* but was renamed *Oceanic*. Note the horse and wagon waiting for the luggage of the passengers who will become guests of the Appledore House.

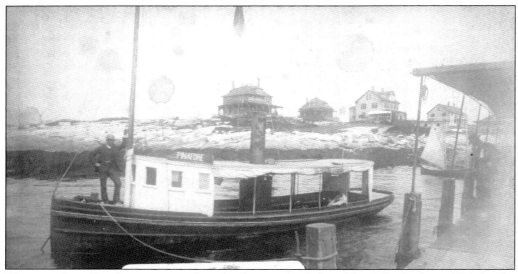

The steamboat *Pinafore* is seen tied at the float at Appledore Island. Built about 1873 for the Laightons, it was lost in the Portland Gale on November 26, 1898. In May 1895, Celia Thaxter mentioned this boat in *An Island Garden*: "the kingfisher that perches on the mast of the faithful tug *Pinafore* (so many years our only link with the mainland in winter)." Childe Hassam illustrated this section of the book with an image of *Pinafore* in watercolors.

This launch, *Sam Adams*, replaced the *Pinafore* in 1898 and had an engine that ran on petroleum. She and her crew were involved in the rescue efforts in one of the worst tragedies in the islands in the 20th century. On July 17, 1902, at about 2:20 p.m., the headwaiter, his assistant, and 12 waitresses from the Oceanic Hotel went for a sail with a local fisherman, Frederick Miles. Conditions were not good and when the steamer S.S. *Merryconeag* came into sight the passengers of the sailboat moved to one side of the boat, causing it to capsize.

Mary Marshall (1881–1902) was one of the Oceanic Hotel waitresses that drowned when the boat turned over. The boat the waitstaff was in was a 17-foot whaleboat, schooner rigged, typical of the fishing boats used at the Isles of Shoals. It had passed the wharf at Appledore and was heading back to Star Islands. The passengers made their fateful move to the port side just when the wind came up. Captain Miles tried to let the sail go, but things happened too fast.

Eva L. Marshall (1879–1902), a sister to Mary, also drowned on July 17, 1902. There were three sets of sisters among the 14 that were lost in this accident. The waitresses' dresses were long and when the dresses were soaked, their weight pulled them down. Even swimmers among them lost their lives because of the heavy water-soaked skirts.

Peter Peterson (1878–1957) was working on the *Sam Adams* as the engineer with Capt. Charles Allen. They had just discharged passengers at the Star Island dock when the boat carrying the waitresses turned over. They immediately headed out to rescue the girls but only managed to save one. Fishermen from Star and Smuttynose Islands also set out but only were able to retrieve bodies. Capt. Frederick Miles, who could not swim, was able to grab on to a wooden soapbox and survived. He was found not to be at fault for the tragedy.

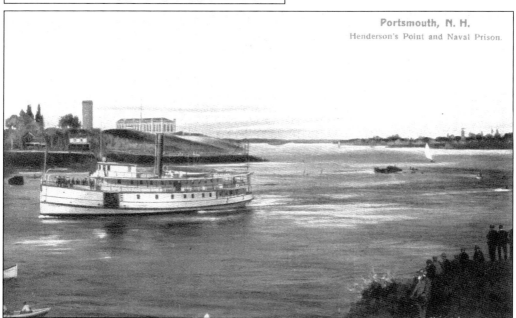

The steamboat *Mineola*, built in Maine in 1901, served the Isles of Shoals during the summers of 1904–1905. In 1905, she carried delegates of the Portsmouth Peace Treaty to Appledore Island on the invitation of Oscar Laighton.

This Davis Brothers' stereopticon view shows the sidewinder *Favorite* taking on passengers. There was no pier at Appledore Island in 1873, and passengers had to take the small boats, as seen in the photograph, for the last 100 yards to the shore. The Oceanic Hotel was built in 1873 on Star Island with a long stone pier that enabled the steamer's passengers to go on and off the island directly. The Oceanic Hotel can be seen in the background to the right. In 1874, the Laightons built a pier on Appledore Island.

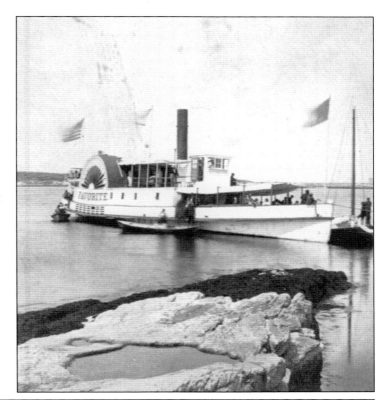

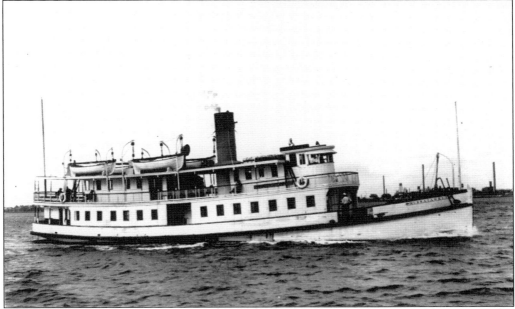

The steamboat *Munnatawket* was built for the Fisher Island Navigation Company in 1890. Munnatawket was the Pequot tribe's name for what became Fisher Island, New York. It carried passengers from the Connecticut shore, to and from Fisher Island. In the years 1909 and 1911 it served the Isles of Shoals.

These ladies are heading to Star Island on a summer day around 1911. This photograph was in a scrapbook in the Star Island collection; nearly all the pictures and personal items deal with Star Island and conferences. There is little doubt that this group was in attendance at an island conference.

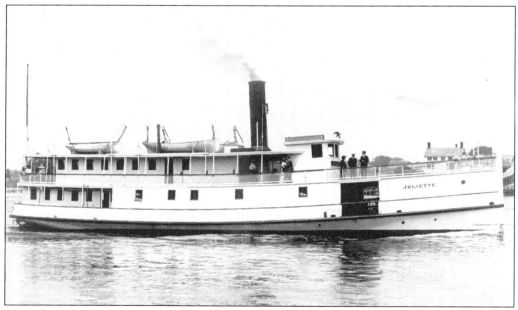

The *Juliette* served the Isles of Shoals in the years 1912–1915. Note the large eagle on top of the wheelhouse. This boat, like many others that served the Isles of Shoals, also worked in other places, notably the Casco Bay region of Maine. Some other Isles of Shoals boats that worked in this region are *Merryconeag* (1901–1902), *Mineola* (1904–1905), and *Forest Queen* (1908).

It was once said that "ladies of Boston did not buy hats—they had hats." It was 1913 that United States Congress passed the Migratory Bird Act, the last of a series of laws aimed at protecting wild birds who were being harvested so their feathers could decorate ladies hats. This effort began in Boston in 1880 and launched the Audubon Society. The ladies going to the Isles of Shoals on the *Juliette*, around 1913, no doubt are proud of their hats without wild bird feathers.

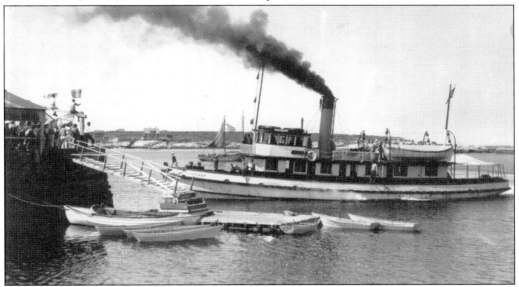

The *Sightseer* worked the seasons of 1910, 1916, and 1919 to 1941. She was the last steamboat on the Isles of Shoals run. In this photograph, taken in the 1930s, she is coming around to land at the pier on her port side. Note the crew member on the main deck with the line. The passengers have lined up on the top deck to disembark and one can see the wake of the turning boat. Oscar Laighton is in his boat *Twilight* between the pier and float.

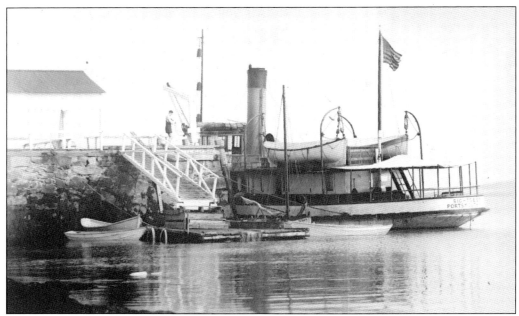

The *Sightseer* is tied to the Star Island dock between ships some time in the 1920s or 1930s. Note the man in the bathing suit of the period and the "keep off" sign on the dock. The rowboats at the float are for the use of the island guests.

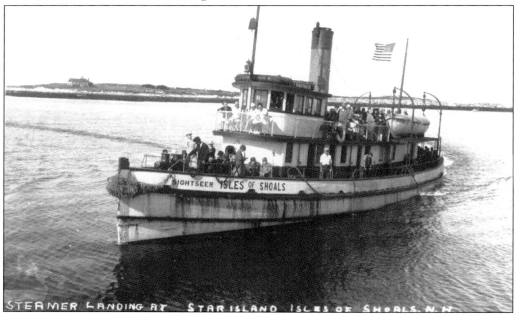

The *Sightseer* is once again approaching the pier at Star Island with a full boatload of passengers. The crew member is ready with the line to make her fast. The passengers are less formally dressed than has been seen in earlier photographs. This group on the boat has no idea they may be some of the last to visit Star Island and ride the *Sightseer* for a long time. In 1941–1945, the islands were closed for World War II. The *Sightseer* went to the government and did not return to the Isles of Shoals.

Joyful anticipation is read on the faces of the passengers of the *Sightseer* waiting for the word that it is safe to disembark. Each summer brings the boats, and the boats bring happy passengers to the conferences at Star Island.

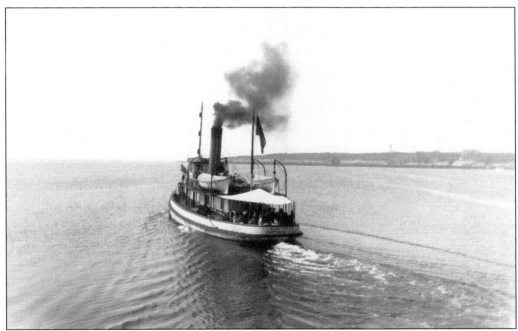

The *Sightseer* heads to Portsmouth on a warm summer day. The passengers have paid their bills and said their good-byes. They are all gathered on the aft section under the canopy, taking a last look at Star Island, where most of them have spent a week in a conference. The staff has most likely bid them farewell with the traditional cheer "S-T-A-R, S-T-A-R, Oceanic, Oceanic, Rah, Rah, Rah, You Will Come Back!"

Star Island reopened after World War II in 1946. The *Kiboko*, a boat with a diesel engine, became the ferry to Star Island; steamboats were a thing of the past. She made her runs to the island until 1961.

The *Kiboko* is at the float at Star Island sometime in the 1950s and seems to be waiting for last minute passengers to go back to Portsmouth. The summer dress certainly has changed since the early 20th century. The two men in suits are the exception to the informality of the others in this picture. The old lifesaving station on Appledore Island is in the background.

The *Viking* serviced Star Island from 1962 to 1968. One day in the summer of 1967, the captain radioed Star Island that the fog was too thick, and he could not find the pier. The island music director, Gary Feurer, gathered the Pelican staff on the rocks by the pier. With perfect pitch they chanted "fog horn," guiding the boat to the pier. The next year Capt. Arnold Whittaker installed radar on the *Viking*.

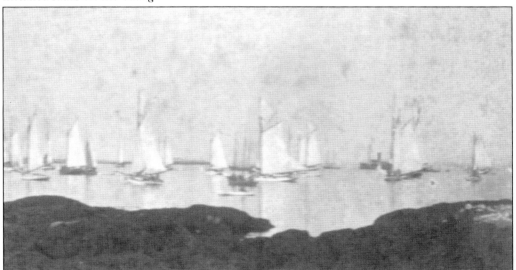

John Poor organized a sailing regatta for the grand opening of the Oceanic Hotel on Star Island in 1873. Oscar Laighton notes that 500 boats came. More than 50 participated in the race, which started at the Isles of Shoals, went around Boon Island, and back. The famous yacht *America* won the race. *America* was acquired from the Naval Academy in the same year by Gen. Benjamin F. Butler, who was on board for the race. In the photograph are some of the boats that came for the regatta as well as one of the island steamers.

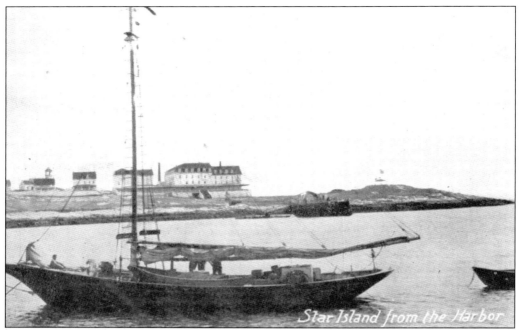

This fishing sloop is typical of the workboats found at the Isles of Shoals around the beginning of the 19th century. This type of boat was in common use in the inshore fisheries. Note the clipper bow and the dory on board.

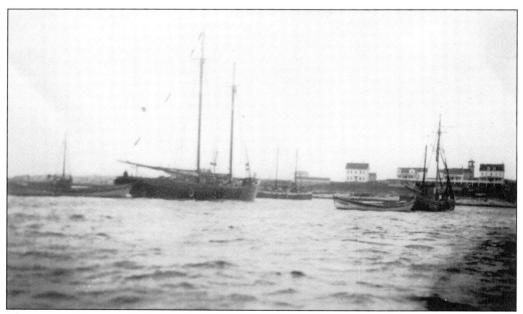

This scene of Gosport Harbor depicts the types of boats that frequented the harbor in the early 20th century. In this view, two large schooners and whaleboats are seen. Both types of boats were common in the inshore fishing industry in the late 19th and early 20th centuries.

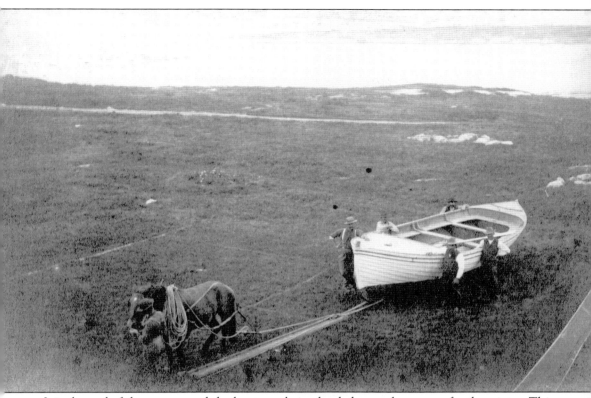

It is the end of the season, and the boats are being hauled up and put away for the winter. This one is being pulled across the tennis courts on Appledore Island. Oscar Laighton, in his book *Ninety Years at the Isles of Shoals*, tells about the first horse coming to Appledore Island in 1863. His father did not like the idea, as he thought horses were dangerous. Nevertheless they acquired a gentle horse named Black Bess and were able to deliver the horse and a cart on board the schooner *Lone Star*. Black Bess proved a great asset to the island.

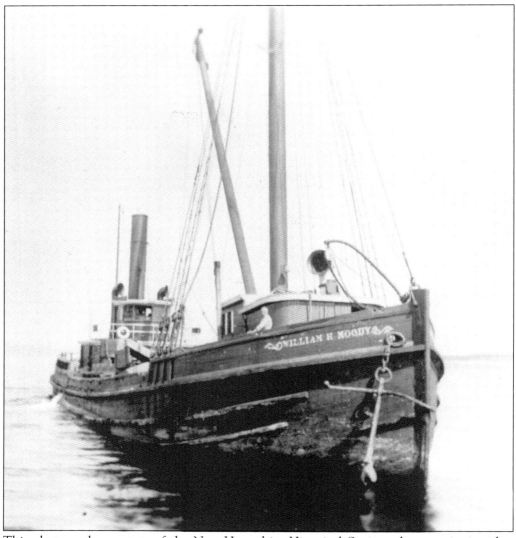

This photograph, courtesy of the New Hampshire Historical Society, the organization that built the Rev. John Tucke (1702–1773) Monument on Star Island in 1914, shows the workboat *William H. Moody*. The site for the monument was purchased from the Piscataqua Savings Bank of Portsmouth, which owned Star Island at the time. The *William H. Moody* was owned by the Pigeon Hill Granite Company of Rockport, Massachusetts. This boat brought the machinery and the granite blocks weighing from 9 to 11 tons each.

As the *Sightseer* heads back to Portsmouth at the end of a day, the echoes of the cheer "you will come back" are still in the minds of the passengers. Most will come back to Star Island and the Isles of Shoals, some physically and others in happy memories of what has become their spirit's home.

Discover Thousands of Local History Books
Featuring Millions of Vintage Images

Arcadia Publishing, the leading local history publisher in the United States, is committed to making history accessible and meaningful through publishing books that celebrate and preserve the heritage of America's people and places.

Find more books like this at
www.arcadiapublishing.com

Search for your hometown history, your old stomping grounds, and even your favorite sports team.

Consistent with our mission to preserve history on a local level, this book was printed in South Carolina on American-made paper and manufactured entirely in the United States. Products carrying the accredited Forest Stewardship Council (FSC) label are printed on 100 percent FSC-certified paper.